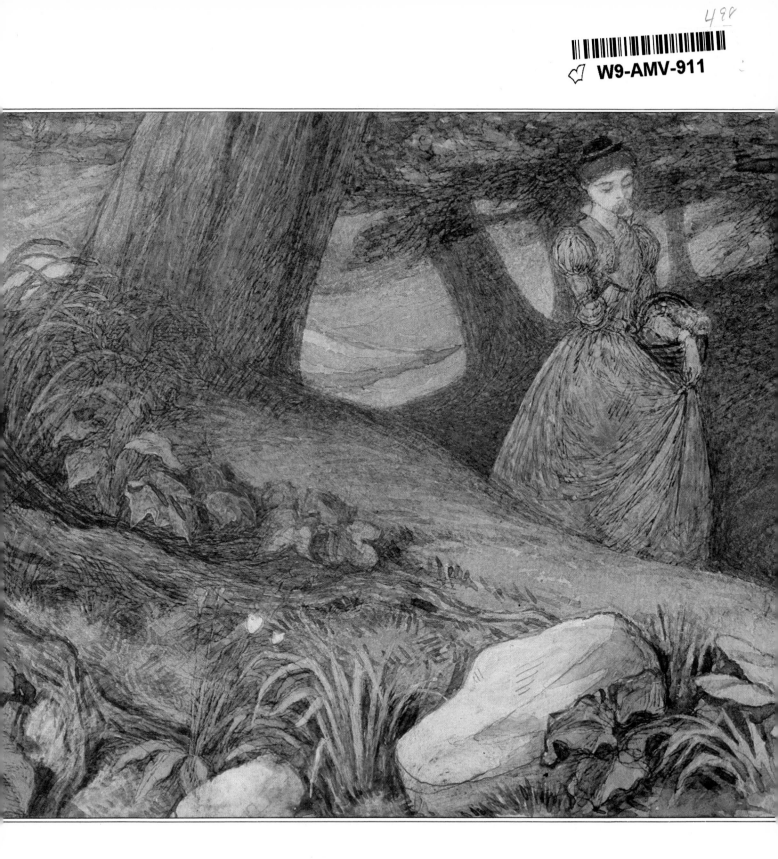

Cover: 128
Front Endpaper: 137
Back Endpaper: 153

Note: Individual entries in the catalogue are initialled:
RE - Rodney Engen;
ME - Michael Heseltine
LL - Lionel Lambourne.

Published by the Victoria and Albert Museum 1983.
ISBN 0 905209 58 3
Copyright of text: Rodney Engen, Michael Heseltine and Lionel Lambourne.
Copyright of illustrations as acknowledged.
Printed by Royle Print Limited.
Designed by Richard Sage and Ray Kyte.

RICHARD DOYLE

AND HIS FAMILY

An exhibition
Richard Doyle and his Family
held at the
Victoria and Albert Museum
30th November 1983 to 26th February 1984

· CONTENTS ·

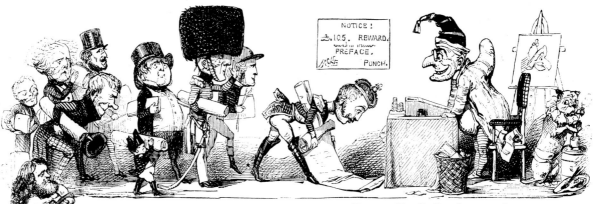

Foreword by Sir Roy Strong 6

The Doyle Family 7

Key to the Doyle Family 9

Chronology 10

The Wizard and the Swell 12

John Doyle 19

The Family 22

Richard Doyle:- Juvenile Works 24

Richard Doyle:- Nonsense Sketchbooks 25

Richard Doyle:- Comic Histories 29

Richard Doyle:- The years with *Punch* 30

Richard Doyle:- Brown, Jones and Robinson 35

Richard Doyle:- Literary Partnerships 38

Richard Doyle:- The Social Scene 40

Fairy Tales and the Supernatural 44

The Fairy World of Dicky Doyle 45

In Fairyland 48

Folk Tales and Legends 52

Country House Visits and Landscapes 56

Charles Altamont Doyle 58

Sir Arthur Conan Doyle 61

A Check List of the Work of Richard Doyle 68

RICHARD DOYLE AND HIS FAMILY

MANY light-hearted subjects like Christmas and Fairies possess far more profound levels of meaning. The present exhibition, which examines the career of Richard Doyle, one of the most brilliant of Victorian painters of the fairy world, the centenary of whose death in 1983 it commemorates, will also prove, I hope, to have its serious side. The Doyle family was, and is, one of the most distinguished British families of the 19th and 20th centuries and this exhibition demonstrates, to use the words of Sherlock Holmes, Sir Arthur Conan Doyle's alter ego — that 'Art in the blood is liable to take the strangest forms'.

In the organisation of this exhibition the greatest possible help has been given by Lady Bromet, D.B.E., Sir Arthur Conan Doyle's surviving daughter, who until her retirement was Head of the Women's Royal Air Force; Brigadier J.R.I.Doyle, O.B.E., the son of Sir Arthur Conan Doyle's brother Brigadier-General Innes Doyle, and other members of the Doyle family. To them, and to all other lenders to the exhibition, we extend our warm thanks, which are also extended to our friends in the art trade who have helped to trace elusive works. The exhibition has been organised by three Doyle enthusiasts, Rodney Engen, whose biography of Richard Doyle accompanies the exhibition; Michael Heseltine of Sotheby's, a life-long collector of Richard Doyle's work; and Lionel Lambourne, Assistant Keeper of Paintings in this Museum.

Sir Roy Strong
Director, Victoria & Albert Museum

THERE are certain families in English history which span the centuries, producing in generation after generation talent of a rare order, a hereditary life force which, handed on across the years, creates men and women of distinction and originality. Some famous examples are the Terry family which for over a century have graced the English stage; the Wedgwoods and the Darwins, whose intermarried families achieved such distinction in the decorative arts and the sciences; the Treveylans in historical research, and the Churchills in politics. Families of artists are of course by no means uncommon, particularly in specialised disciplines. Examples abound in sporting painting with the Sartorius, Alken, Herring and Ferneley families, in watercolour painting with the Varleys, Prouts and Richardsons, miniature painting with the Engelhearts, and in the wider realm of twentieth century art the Bell, Nicolson and Rothenstein families — all have possessed the mysterious gift of handing on hereditary talents.

To examine the history of one of these families can be rewarding on several levels, not only from the artistic point of view. For we are all intrigued by family history, by the impact of one generation on another, and the interaction of hereditry and environment and the part they play in the formation of character. This exhibition takes as its theme one of the most remarkable of these families, the Doyles. It is occasioned by the centenary of the death of one of its most distinguished members, Richard Doyle, on December 11th, 1883. Richard was a matchless recorder of the social scene, but is remembered as one of the most brilliantly innovative of the group of Victorian painters who devoted themselves to the theme of fairies, which then held an attraction analogous to that of Science Fiction today. The exhibition cannot hope to do full justice to all the other members of the family, and may indeed be justly criticised for presenting its greatest figure, Sir Arthur Conan Doyle, Richard's nephew, in an unfavourable light, by inevitably concentrating on the Cottingley Fairy affair, which was such a minor incident in his distinguished career. But it seems worthwhile to attempt to place Richard Doyle in the context of the family which meant so much to him. Full biographical details of each personality are given under individual headings, but this introduction will examine some of the creative impulses which recur and link different generations of the Doyles.

The Doyles trace their descent from an old Norman family which came originally from Pont d'Oilly near Rouen in Normandy. They took part in the conquest of Ireland, and in 1333 Alexander d'Oilly was granted lands in County Wexford by Edward III. Roman Catholics, the Doyles of the seventeenth and eighteenth centuries were gradually evicted from their lands, but their distinguished lineage was always to be important to them, and was to play its part in the interest in several members of the Victorian family in mediaeval history and romance.

John Doyle, the founder of the Doyle family of artists, was born in Dublin 1797, and trained initially as a miniature painter under John Comerford, before settling in London in the 1820's and gaining fame as a political caricaturist, working under the nom de plume HB. Caricature, by definition, is an art of exaggeration — the word's original Italian meaning being to charge, to overload a linear portrait with heavy, expressive distortion. John Doyle suprisingly eschews this technique in his straightforward, truthful portraits, very different from the savage, satirical likenesses of his predecessors Gillray and Rowlandson. His humour was obtained, not by exaggeration, but by portraying his subjects with the utmost veracity, so that we see in the faces and bearings of the politicians of the era the stress and strain of their vocation.

This fidelity of expression and accuracy of delineation was supplemented in his work by constant resource to allusive paradox. Thus he uses, for example, a scene depicting the Three Witches in *Macbeth* to satirise three politicians cooking up a potent brew of evil, or Don Quixote tilting at windmills to stigmatise an act of idealistic political folly. Turning the pages of the eleven volumes of *HB's Political Sketches* one marvels at John Doyle's extremely extensive use of this visual armoury of allusive comparison. In his work one of the two salient aesthetic qualities of the Doyles predominates — a keen regard for truth in artistic expression.

Although not therefore, as an artist, of great originality or imagination, as a father he was ideally qualified to train, in the most practical manner by example, his artistically gifted children. But while all the children were expected to draw and paint as a matter of course, they were to utilise their training in different ways in later life. James, the eldest son, (1822-1892), who from an early age had a passion for history, was to abandon his early attempt to become a historical painter to write and illustrate his *A Chronicle of England,* 1864 and *Historical Baronage of England,* 1886, the latter work being still in use today as a standard reference book at the College of Arms. Henry (1827-1892) also initially worked as a painter and illustrator, before turning to art history and administration, becoming Director of the National Gallery of Ireland in Dublin. But it was Richard and Charles who were to develop in their very different careers as artists, one successful, the other obscure, the other salient Doyle quality — vivid imaginative powers and an intense interest in fantasy and the supernatural.

Richard's career presents a fascinating balance between these two salient poles of the Doyle creative impulse — the concern with truth and the realms of fantasy. John Doyle's early training in truthful observation can be studied in the delightful *Dick's Journal of 1840,* drawn for his, and his father's eyes alone. It draws in word and line an attractive picture of the daily life of the Doyle children, and abounds in sharply observed vignettes of the London of the 1840's. In it we can vicariously experience an evening at the opera, a royal procession, a trip on the exciting new mode of transport the railway, and visits to galleries and shops. This ability to record actual events with objectivity tempered with wit was to feature in such later works as *Ye Manners and Customs of Ye English,* 1849, and *Bird's Eye View of Society,* 1864, and most delightfully in *Brown, Jones and Robinson,* the account of his only trip abroad which was to enjoy a vogue which anticipates Jerome K. Jerome's *Three Men in a Boat* and its sequel *Three Men on the Bummel,* which incidentally covered much of the same journey.

One of the most memorable images in *Dick's Journal of 1840* shows the young Richard in bed surrounded by the teeming hordes of fairies which already obsessed his imagination, and although he excelled as a visual reporter of the social scene it was in the secret world of fairyland depicted in his paintings that his genius achieved its full stature. His work in both genres has suprisingly much in common, for present in both are the same delight in crowds, the same interest in inter-linking groups in action, but in the fairy paintings Richard's sense of mischief has full rein. While it is easy to cite his antecedents, Grandville and the Romantic Ballet, Croker's and Keightley's books of fairy stories, it is more rewarding to comment on where his work differs from that of other Victorian painters in this particular genre. They all took the subject a little more seriously than it deserves. Noel Paton, Maclise, Fitzgerald and notably because of his insanity Richard Dadd — in none of them do we find the glee, the gaiety, the sense of mischief which enables Richard Doyle on the whole to avoid the mawkish pitfalls which beset the fairy painter.

In the life and work of Charles Doyle, the youngest of John's sons, (1832-1893) the imaginative, fantasy strain in the Doyle genius is seen at its most extreme. He was at one and the same time both the weakest and the most vital of John Doyle's sons, for it is through him, and his marriage with the remarkable Mary Foley, the 'Ma'am' that the family was carried on, all his brothers dying without issue. Charles's life was a tragic one — the tragedy of an imaginative man unable to cope with banishment at an early age from the close knit London home of the Doyles to a humdrum job as assistant surveyor in the Scottish Office of Works at Edinburgh, unable to cope with the ever growing demands of his own large family, unable to withstand the attractive anodyne of alcohol. He took refuge at Sunnyside (was ever lunatic asylum more euphemistically named?) in the fantasy world of his sketchbooks, with results which give a manic, and at times frightening dimension to the realm of fairy painting. His work has a hallucinatory quality which haunts the imagination.

In his son Sir Arthur Conan Doyle's remarkable career the many different elements of the Doyle family's unusual talents found their fulfillment. In his works, which range so widely across the whole field of literature, we find the exact eye for the delineation of individual human character which so distinguished the political portrait caricatures of John Doyle-HB; the passionate interest in history which animated James, while the talent for administration which made Henry a great Museum Director, found an outlet in his Chairmanship of a host of bodies varying from the Divorce Law Reform Society to the Fields Sports Association. But it was from his father Charles, and Uncle Richard, that he inherited the richly imaginative and endlessly inventive mind which produced such memorable creations as Sherlock Holmes, Professor Challenger and Brigadier Gerard. From them also he acquired the interest in fairies which was to lead to his involvement in the Cottingley fairy affair, which for over half a century has refused to leave the headlines. Of this incident, fully discussed in the final section of the catalogue, it suffices to say here that Conan Doyle's own integrity over the question of the photographs veracity cannot be doubted, and that he himself certainly believed that they had been subjected to the most stringent scientific tests then possible. That he should state his belief in fairies has deeper implications, which complex though they are, can be understood in the light of his deep despair at the materialism of the post world war society, and the very regard for truth which led to his firm conviction that paranormal experiences should be fully investigated.

Of the family today, much could be said, for its senior members have served with great distinction in the armed forces. But it is perhaps most fitting to conclude by stating that a contemporary Richard Doyle aged eighteen, and his sister Catherine, have both artistic abilities of a high order, and to speculate, as does Sir Arthur Conan Doyle's famous character Sherlock Holmes upon the way in which 'Art in the blood is liable to take the strangest forms'.

LL

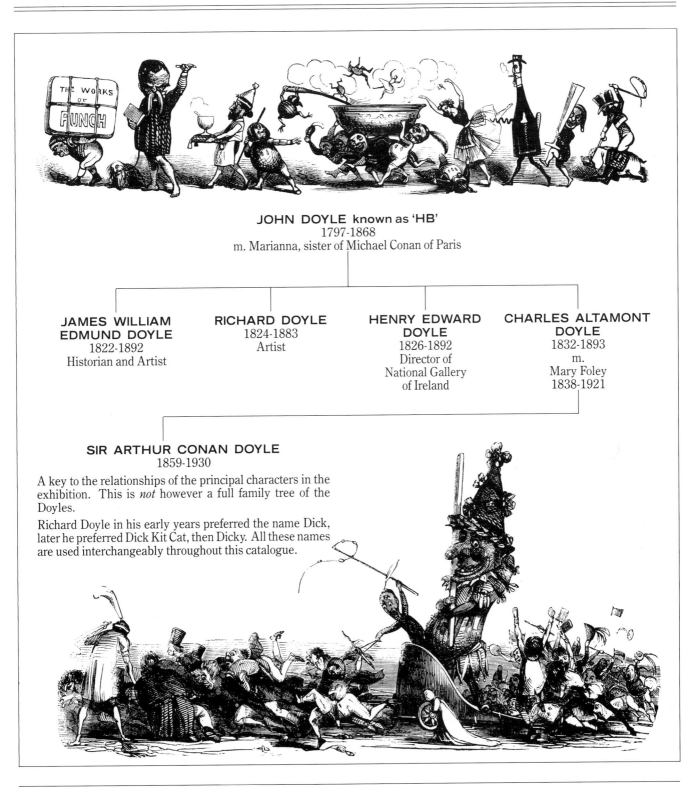

JOHN DOYLE known as 'HB'
1797-1868
m. Marianna, sister of Michael Conan of Paris

JAMES WILLIAM EDMUND DOYLE	**RICHARD DOYLE**	**HENRY EDWARD DOYLE**	**CHARLES ALTAMONT DOYLE**
1822-1892	1824-1883	1826-1892	1832-1893
Historian and Artist	Artist	Director of National Gallery of Ireland	m. Mary Foley 1838-1921

SIR ARTHUR CONAN DOYLE
1859-1930

A key to the relationships of the principal characters in the exhibition. This is *not* however a full family tree of the Doyles.

Richard Doyle in his early years preferred the name Dick, later he preferred Dick Kit Cat, then Dicky. All these names are used interchangeably throughout this catalogue.

1797	John Doyle born in Dublin
1822	James William Edmund Doyle born in London in October
1824	Richard Doyle born in September
1827	Henry Edward Doyle born
1829-41	*HB Political Sketches* first published
1832	Charles Altamont Doyle born, shortly after Marianna Doyle dies
1836	Richard Doyle's first juvenile book, *Homer for the Holidays*
1840	*Dick Doyle's Journal, The Tournament,* Fores envelopes
1842	HB's career fades; Richard Doyle juvenile works include *Jack the Giant Killer, Beauty and the Beast, Grand Historical Procession*
1843	Richard Doyle joins *Punch* in November; first published etchings in *Hector O'Halloran*
1844-47	Illustrations to Dickens's Christmas Books
1846	*The Fairy Ring* illustrations establish Richard as a fairy artist
1848	Richard Doyle's *Selections from the Rejected Cartoons;* Oliver Goldsmith; *L'Allegro and Il Penseroso*
1849	'Manners and Customs' series appears in *Punch;* publishes Montalba's *Fairy Tales; The Enchanted Doll, Juvenile Calendar.* Charles sent to Edinburgh
1849-50	Thackeray commissions *Rebecca and Rowena*
1850	Brown, Jones and Robinson first appear in *Punch;* Richard visits the Continent; Richard resigns from *Punch* in November
1853-55	Thackeray's *The Newcomes* illustrations
1854	*The Foreign Tour of Brown, Jones and Robinson* published
1858	*Scouring of the White Horse* illustrations published
1859	Arthur Conan Doyle born in Edinburgh
1863-64	Richard Doyle's 'Bird's Eye Views of Society' published in *The Cornhill*
1863-65	James Doyle's *Chronicle of England* published
1865	Richard Doyle's *Works of Frederick Locker; An Old Fairy Tale Told Anew* published
1868	2 January John Doyle dies
1868, 1871	Richard Doyle exhibits at the Royal Academy
1869	Henry Doyle appointed Director of National Gallery of Ireland
1870	*In Fairyland* published, also *Piccadilly*
1874	The Doyle family entertains Arthur Conan Doyle in London
1878-83	Richard Doyle exhibits at the Grosvenor Gallery
1883	11 December Richard Doyle dies
1885	Posthumous Richard Doyle exhibition at Grosvenor Gallery
1885-86	James Doyle's *Official Baronage of England* published
1886	Richard Doyle estate sale, Christies, 7 June
1892	Henry Doyle dies 17 February, followed by James Doyle 3 December
1893	Charles Doyle dies 10 October
1930	Sir Arthur Conan Doyle dies

RE

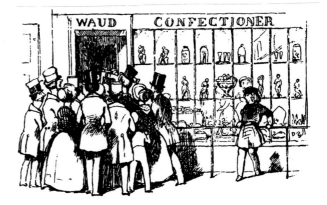

HE left behind him the memory of a singularly sweet and noble type of English gentleman, and of an artist of 'most excellent fancy' — the kindliest of pictorial satirists, the most sportive and frolicsome of designers, the most graceful and sympathetic of the limners of fairyland. In Oberon's court he would at once have been appointed sergeant-painter. (Austin Dobson in *Dictionary of National Biography*).

Such was the summary of Richard Doyle's influence after his death. And yet his remarkable rise to prominence as a *Punch* illustrator, as well as his role as the creator of such endearing juvenile fantasies as *The Tournament, Scenes from English History* and *Dick Doyle's Journal,* which appeared after his death, did little to restore Doyle's place as an influential Victorian draughtsman and fairy illustrator. Many of his critics claimed his star had risen too soon. He had been a child prodigy with a gift for fantasy, and allowed to express that whimsical brilliance in the exalted social circles which appreciated escapism as entertainment. But the elation and excitement soon faded; the Doyle childish spirit, which he retained throughout his career, soon palled. Lewis Lusk, Doyle's greatest disciple and thwarted biographer perceptively noted in *The Art Journal* in 1902: 'Often it happens that a man of delicate genius gives himself to the public in a cheaper form than his best, — makes a hit with it, and goes on in the same style ever after, so far as the public is aware. Doyle did that very thing, very early in life.'

Lewis Lusk's observation is a fascinating but all too common phenomenon for the biographer of artists living during what one redoubtable Victorian hostess called 'the age of publicity'? And Doyle was very much a product of his age. He was trained from childhood by a defiant, self-made father who first exposed him to the principles of respectability which had ruled his own life, and would ultimately dominate Richard's. The first juvenile works were done under this shadow and treated like innocent after-dinner mints to amuse the guests of his father's wealthier friends; books privately printed and purchased after the gentlemen had returned to the ladies in the drawing room to immerse themselves in Doyle's innocent and seemingly unpretentious schoolboy fantasies. Ironically, as time passed and his reputation became better known, his drawings satirized the very audiences in which they were first promoted. The principle of restraint and gentlemanly behaviour dominated Doyle's early life as the member of a large family of staunch Catholics, proud of their Irish ancestry. He and his brothers were trained in the gentlemanly pursuits of fencing, dancing and music as well as literature and the classics, to prepare them for entry into polite society. Dick, as he preferred to be called, grew up with a reverence for his family, the Catholic Church, the Royal family and his country. In an age when the revival of chivalry signalled the return to 'old-time' values of respectability and nationalism, Dick, and his father before him, captured in their drawings the prevailing mood of the respectable rising middle-classes and successfully

appealed to them with drawings of tasteful understatement and comic invention. And in the end, although Dick Doyle retained a social conscience — as seen in his *Punch* cartoons of the tragic Irish peasantry and the war-torn map of Europe — he was most comfortable within the narrow confines of polite Victorian society. For this reason, his social drawings remain amusing as well as accurate pictures of the period; like comic candid photographs they demand careful study to catch the joke, but they are well worth the effort.

At the root of Doyle's social drawings lies his own insular childhood. As a boy in London he submitted to the restrictions placed upon him by his father and developed his draughtsmanship almost exclusively under his tutelage. John Doyle was by then the famous political cartoonist HB, whose 'Political Sketches' had been greeted with immense success and provided the money on which to support his family of seven children. They had touched a vein of restrained, dignified humour lacking in the post-Gillray world of political cartoons, and were clear evidence of John Doyle's unshakeable belief in high moral standards in politics as well as society. His portraits of prominent politicians (many of them personal friends) as well as aristocrats and members of the Royal family, were as much homages as necessary ciphers to be moved about in his comic compositions. At home he was 'the Guv'nor' or 'Lord John' to his children, instilling in his five sons and two daughters the utmost respect for authority. He insisted his identity as HB must never be discussed or revealed, and sent his drawings to the printer in a covered carriage to avoid detection. Artistic distance was essential to his work; a virtue he taught to his children, all budding young artists. The best artist was one who relied totally upon his memory, and fed it daily, upon large doses taken from life, of the sights and sounds around one. He sent each child out into nearby Hyde Park, to the streets of busy crowd-filled central London, or the sacred halls of the National Gallery and Royal Academy. There especially young Dick learned to sharpen up and depend upon his visual memory. He recorded each day's events in masterful illustrated letters to his father, as did all the Doyle children. These letters formed the basis for his delightful *Dick Doyle's Journal.*

The Doyle journal and illustrated letters are indeed a biographer's dream. They chart with remarkable clarity, in careful copperplate descriptions and fine pen sketches, the evolution of Dick Doyle's talent from fantasy-struck schoolboy to serious published illustrator. His father had taught him to stretch his goals until he aspired to become a famous history painter, having been force-fed upon great doses of his father's favourite Horace Vernet. This acknowledged master of huge canvases, with clouds of soldiers in battle scenes of expert composition, had apparently painted his works entirely from memory. Young Dick was told to emulate this stirring example, to study Vernet's paintings for 'groupings', and in response he raced out into Hyde Park each time a military display or royal procession was announced, to collect impressions for later memory drawings. He and his brothers James and Henry managed this with astonishing accuracy, especially drawing horses — which were their father's favourite subjects. But to Dick at least, such escapades were overshadowed by the fear of failure that he might not recall enough details to please the rigorous standards set by his father. He wrote elaborate descriptions of these events, as if to pad out and enhance his drawings, and gradually he found the spectators were just as interesting as the actual military displays. While waiting for a procession he studied the faces in the crowd, listened intently to snippets of conversation, fascinated by the Dickensian characters around him. There were hints of class prejudice in his descriptions of parlour maids and footmen, street sweepers and other 'Cockneys' of the 'lower classes'. But he was generally more intrigued and interested than condescending, for here were strange new subjects of a type infinitely different from the regimented comforts of his own insular middle-class world.

The Doyle household was virtually run by John Doyle following the death of his wife about 1832 (after Charles was born). Fortunately the atmosphere was lightened considerably by the arrival of the Conans, their mother's brother and wife. Michael Conan was a music and art critic for *The Morning Herald*; an endearing character with the light-hearted Irish twinkle in his eye, a fund of stories and a talent for spiking his reviews with clever words and phrases. He taught Dick and his brothers to think critically, and took them to concerts, the ballet and the opera, educated them in the ways of the London season and trained them to not only look at pictures but to enjoy them. It was the best groundwork Dick could have received; his Uncle Michael was like a breath of fresh air to invigorate and instil confidence in whatever he drew or wrote.

On the other hand, Dick Doyle was blessed with a vivid imagination. When left to his own devices he would take out his sketchbooks, which he called appropriately 'Nonsense Books', and practise elaborate fantasy figures and compositions. Like a wizard with a magic wand for a pen, he could pull an astonishing assortment of creatures from a single point on the page; his elves, fairies, sylphs and grotesque monsters explode from doorways or swirl through the clouds in intricate layers. Here he was free from his father's restrictive lessons, his imagination

given full reign, at times relying upon subjects from his store of folk legends or readings in history, of stories by Walter Scott ('the wizard of the north'), or Keightley. There seemed to be no real order to his subjects; the drawings were mere boyhood fantasies which remain the supreme expression of Doyle's inventive talent. He used them in his first published book designs; they became keys to his future as an imaginative and unique illustrator of the book. From his Fores envelopes, *The Tournament, Jack the Giant Killer, Beauty and the Beast* to *Scenes from English History*, all his juvenile works showed how much he relied upon invention at the expense of realism. His historical characters of exaggerated faces and diminutive bodies are comic jesters, expressions of Doyle's own distrust of text-book history. But then he had been forced to read and translate a painfully large number of history books by his tutor; the hours spent only increasing his frustration at not being able to draw what he liked, as he saw history might have been like.

Fantasy was a vital part of Doyle's development. According to his journal, he was kept awake at night by visions of fairies and puckish gnomes which, try as he might, he could never quite stay awake long enough to capture on paper. He loved the theatre and ballet, where troupes of Bottoms and Ariels, Prosperos and Calibans as well as swirling companies of ballerinas fed his imagination and inspired his early drawings and watercolours. Like Prospero in his 'The Fairy Tree' he was the artist-wizard who could sweep his pen across the page and fill it with fantasies. He sought out the sylvan painters in the galleries, admired Richard Dadd, as well as Poussin and the Italian Old Masters, studied illustrations by Cruikshank, Maclise as well as Grandville. But just as one dismisses his obvious influences in one sentence, it is important to note how Doyle's fairy drawings forced him out from the crowd of imitators which peopled the mid-Victorian galleries. In an era when fairy subjects were given serious consideration, sought out and purchased by the Queen and her consort, Doyle was an exciting new discovery. Needless to say the Queen was among Doyle's many admirers from the time he was given a vehicle with which to express himself for a larger audience.

That vehicle was the weekly issue of *Punch*. Doyle had been asked to join the paper in 1843, at the age of nineteen, and over the seven years he spent as its comic artist he established himself as a major comic artist. *Punch* was the mouth-piece of the growing middle-classes, aware of political issues yet thirsty for the frivolous, the entertaining as well as the provocative. Since 1841 its early pages had been lightened by a weekly cartoon and slight fantasy engravings after drawings by Kenny Meadows and John Gilbert. When Doyle arrived, his 'Nonsense style' was quickly recognised for its whimsical character, and he was given numerous opportunities to elaborate upon boyhood experiments with fantasy and historical characters in his *Punch* initials and border designs. He poked fun at the art world in a series of comic plans for monumental sculpture after national heroes; he spoofed the American gold rush. In time he shared

with John Leech the weekly full-page political cartoon and brought to subjects chosen by all the staff his own brand of fantasy and carefully observed political portraiture (echoing his father's influence). From the start Mr Punch proved an exhilarating and exhausting employer, and Dick was devoted to the work. No longer could he jump from one unfinished project to another, as he had done at home for his father. The *Punch* demands of weekly deadlines, annual almanack borders, unexpected Special Number issues, taxed his strength and left little time for drawings in the manner set out by his father (who had objected to his son's vulnerability and the influence of 'the wicked Mr Punch').

Through his *Punch* work Dick made numerous friends with some of the period's most influential and talented writers and comic artists. The paper's editor, Mark Lemon, was an endearing, jolly and compassionate employer; the fiery-tongued journalist Douglas Jerrold provoked and in the end upset Dick's carefully formed standards of respectable press behaviour. The *Punch* editorial meetings were heated, hilarious yet productive affairs, and afterwards Dick was sometimes taken in hand by mischievous colleagues like Thackeray, or that friend of *Punch*, Charles Dickens, and exposed to the less respectable delights of 'bohemia'. A young man in his early twenties, Doyle relished these excursions to coffee houses and cider cellars along the Thames; they were a considerable initiation into the adult world free from the restrictions of his family (with whom he continued to live most of his adult life).

Doyle's respect among the *Punch* staff was great, and in turn *Punch* gave him the boost and reputation which would establish him as a major comic illustrator. His first real triumph came with the comic drawings 'The Manners and Customs of the English', which accompanied Percival Leigh's fictitious Mr Pips's diary accounts of London society, street life, and entertainments during the season. Doyle mastered a rather crude cut-out style for his crowded figure compositions, but with an endearing quaintness which captured *Punch* readers. The original series led to a second (without the Pips diary) as proof of how firmly the Doyle magic had taken effect. On the strength of his *Punch* work and his growing friendships in literary circles, he was invited out into society and delighted his hostesses with his shy, quiet manner, yet endearing wit. He became the 'London swell' and delighted in the opportunity to collect and observe incidents in society. The experience inspired his second *Punch* triumph: the comic trio Brown, Jones and Robinson. Here were three delightful young bachelors typical of the scores of eligible young men who descended upon London during the season in an attempt to break into London society. It was a familiar goal to Dick and his brothers, and according to the comic antics he devised for the trio, he had found the whole experience daunting, frustrating, yet well worth the effort. For from the *Punch* period onward, Dick Doyle would delight in his excursions into polite society. On the other hand, his Brown, Jones and Robinson characters seemed doomed to failure. Dick took them to the races, trained them to dance the polka — the newest dance craze

— and to ride well enough for Rotten Row. He even followed their progress at their first society ball — which ended in disaster. Indeed, each episode contained some minor upset or comic *faux pas* to delight the pretensions of the *Punch* readership. However misguided or inept their attempts to make themselves agreeable in society, the trio could not fail to amuse. Later Doyle travelled to the Continent with two *Punch* colleagues (the models for Jones and Robinson, Doyle being the original Brown), and used their experiences abroad for the immensely successful travelogue, *The Foreign Tour of Brown, Jones and Robinson* in 1854. Here again he had masterfully touched on the delicate subject of British tourists abroad, capturing their foibles, self-obsessiveness, the snobbishness and innocence of the Victorian abroad. Even the most serious events were turned into comedy as Dick used his boyhood ability to see the ridiculous in unexpected places. The background was set firmly in war-torn Europe where border guards and constant passport checks were alarming interruptions to travellers. Doyle deflated the tension with incidents like the arrest of young Brown for sketching on a mountainside; when the irate border police confiscated his camp stool as a dangerous weapon, his sketches as evidence of spying. Surely this was not reality but some laughable joke played on an unsuspecting tourist by a distant, foreign power. As such it was a ripe subject for Doyle's satiric pen.

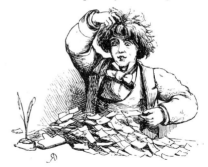

Dick's characterization of Brown, Jones and Robinson helped to establish their creator as a household name and his creations as national heroes — or rather anti-heroes. Sadly their appearance in *Punch* was short-lived. Douglas Jerrold's savage attacks combined with Leech's cartoons to head the *Punch* campaign against the so-called 'papal aggression' — the decision by the Pope to re-establish Catholic bishops in England. Throughout the late 1840s the displays of anger, the riots and violent attacks on Catholic churches fed public outcries, and *Punch* helped to fan the flames of dissent. Dick Doyle was an acknowledged member of the Catholic Church, whose proud family connections were well-known among prominent Catholic figures. He felt he could no longer be associated with the *Punch* position and resigned his post in November 1850. Never again would he accept work for a national paper of Punch's power, although the offers came — and were rejected. Instead he accepted his situation; as the most famous member of his family — HB's career had all but dried up — he had a responsibility to them which reached further than his immediate artistic ambitions.

For the next thirty-three years Dick Doyle lived the uncertain life of the professional illustrator and painter. He called up all his familiar powers as the 'wizard and the swell' to create works of fairy fantasy and social comment. For the biographer he sank into a sporadic output of delightful books and watercolours for the galleries, hiding his personal life behind a daunting round of social engagements in London and the country. His character was universally admired for its shy, self-effacing qualities; he had a childish wit and an ability to tell a story and hold his audience rapt in attention. But his artistic ambitions were plagued by a nervous fastidiousness which caused even his best-laid plans to suffer — not for lack of ideas but single-minded dedication to complete a project. Even as a child he had been easy prey to tempting diversions which hindered his progress. And now, as he accepted a number of different book commissions, especially from the Dalziel brothers, his work and his reputation suffered the same fate. There always seemed to be something more interesting to do: a session of Parliament to attend to lobby for a favourite bill or to interest a new government in his father's bid for a government post, or commissions for paintings for his brother James which he tried to find among his wealthier friends, as well as a constant flow of encouraging letters written to help his deeply troubled brother Charles, in exile in Edinburgh. He also spent a great deal of time at his clubs, where he carried on the necessary correspondence and made the important connections which kept his full social schedule such an essential part of his life until his death.

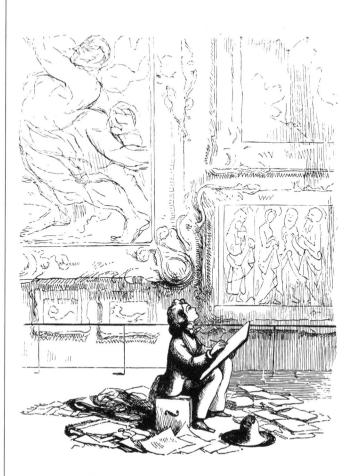

During this period, the romantic strain in his work was given full reign in his drawings for Thackeray's *Rebecca and Rowena,* followed by *The Newcomes.* Both were filled with scenes of romance in historical or contemporary guises. Like Thackeray he regretted the so-called marriage market — the marrying-off of young ladies to wealthy and well-connected bachelors by scheming relatives. It was the basis of *The Newcomes* story, which provided Doyle with his most troubled and turbulent commission, taxing his long friendship with Thackeray to the limit. Moreover, Doyle was a disciple of the age of chivalry, and believed women should above all be admired, rescued if in distress, and revered for their beauty. His own romantic attachments were wholly from a distance — he lived up to his father's dictum in life as well as art. He studied young women in drawing rooms and crowded streets, in the country houses where he spent greater amounts of time, and later commented on their beauty in his letters. This set the scene for the one tragic love of his life, a cruel flirtation which inevitably ended in sorrow and frustration. Again the real world failed to live up to his expectations while the innocent world of fantasy beckoned with reassuring regularity.

When Doyle provided his friend Charles Dickens with illustrations to three of his Christmas books, he based his drawings upon fantasy as well as his own family's troubled life at the time. And when Thackeray later appealed to him for new illustrations, this time for *The Cornhill,* Dick offered a series which could be seen as a more discerning look at society after over twenty years of dinner parties and At Homes. He called the series 'Bird's Eye Views of Society' and when they were eventually published in book form, with his own descriptions of the comic events, they showed a decidedly different view of London life. Here, grotesquely decorated drawing rooms are filled with equally grotesque philistines, asleep in their chairs or adding their numbers to already overcrowded rooms. A children's party looks more like an adult soirée; a Science and Art Conversazione becomes a hectic jumble of artists selling their work and famous personalities displaying their knowledge to the ignorant. If bitterness is the overall theme of these drawings, in the over-opulent interiors, the gluttony at table and rich fashions, then Doyle still had the ability to sugar-coat his criticism, for his drawings are filled with intricate and amusing detail in costumes, facial expressions and ridiculous poses. Again all this had been observed from a distance, for Doyle was well-known for his favourite position at the door, where he stood quietly chuckling to himself as society paraded past him. He was the supreme observer using, in today's phrase, the 'fly on the wall' technique of observation, and the results remain some of his best social satires.

Doyle had made his name as a fairy-tale illustrator with his drawings to *The Fairy Ring,* 1846, a new translation from the Brothers Grimm. Thackeray had greeted this one book with rapturous praises, and subsequent fairy story commissions and books suited to the Doyle style of fantasy followed. And, while an erratic collection on the whole, when they are good, they are unsurpassable. The rich vein of fairy fantasy was half-heartedly mined by Doyle from then until his death — in these books and later watercolour paintings based upon his favourite stories. They reached a culmination in his masterful *In Fairy-land* in 1870. It remains his best-known volume, and rightly so. And yet his publisher felt it necessary to herald its publication with a poetic excuse for why Dick Doyle had been so long out of the public eye:

> *Where had Dicky Doyle been*
> *All this length of years,*
> *Since Punch wept to miss him*
> *From his merry peers?*
>
> *Now last we know where Dicky Doyle has been!*
> *He has been in Elf-land*
> *With the Fairy-Queen.*

Unfortunately with *In Fairyland* came the gradual end to Doyle's illustration career. He had begun to paint watercolours for the London galleries, which appeared at the Royal Academy and regularly at the Grosvenor Gallery from 1878. Many were based upon successful proven fairy formulas, legends taken from Keightley, the Brothers Grimm; some were given long explanatory texts to enhance their appeal. He painted landscapes from views on his friends' country estates, or taken from visits to Scotland en route to visit his brother Charles. Later work was sketchy, heavily stippled and filled with erratic washes of bright garish colours. The press often reviewed his work but patrons were generally restricted to his well-meaning and wealthier friends. He once tried portrait drawing and architectural paintings of favourite country houses in pursuit of new patronage, but soon gave this up when ill-health and social engagements pressed and prevented serious study.

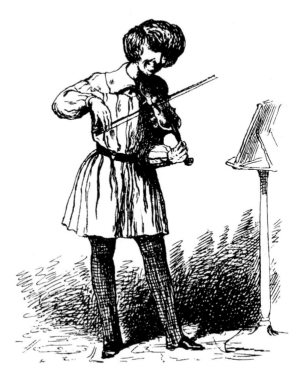

Richard Doyle died on 11 December 1883. His obituaries stressed his endearing character, his gentlemanly quiet manner — and finally his abilities as an artist. Too much time had elapsed to properly assess his importance as a *Punch* artist, or even a fairy illustrator. Later critics of illustration relegated him to the sketchy 'self-taught school of Leech and Cruikshank', overshadowed by the Sixties School illustrators who had shown what strong work could be done from firm academic training. But the rising generation of illustrators acknowledged Doyle: Walter Crane had studied his *Punch* drawings in the paper's office window during his lunch breaks as an engraver's apprentice; Kate Greenaway had launched her greeting card career with designs based upon *In Fairyland*. John Tenniel, who replaced Doyle on *Punch*, continued to borrow from the Doyle style of fantasy, albeit drawn in his own austere, classical line. During his lifetime Doyle had influenced the Pre-Raphaelite painters: William Holman Hunt became a life-long friend and admirer, Millais shared that admiration, as did young Burne-Jones who praised Doyle's *Newcomes* illustrations in print. Most of all they had admired Doyle's uninhibited skill at composition, how he filled a page with figures regardless of conventional rules of perspective — and they bought issues of *Punch* for the 'Manners and Customs' series, whenever they had the money to do so.

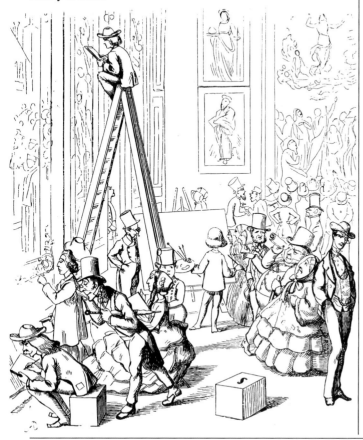

After Doyle's death his brothers and sister tried to keep his reputation alive by consenting to facsimile editions of his juvenile works: the journal, *Scenes from English History, Jack the Giant Killer.* The Montalba fairy-tale volume was reprinted well into the 1890s, when it became something of a tribute volume with a biographical preface to remind readers who Dick Doyle was. But by the end of 1893 all the Doyle brothers had died, and with them went the family's attempt to preserve the Doyle legend. Their favourite nephew Arthur Conan Doyle kept a warm place in his memory for his beloved Uncle Dick, but was more concerned with his own father's artistic reputation. And despite a resurgence of interest among book collectors in the 1920s, and picture dealers in the late 1960s and early 1970s, the work of Richard Doyle remained largely overlooked by all but the specialist. And yet it is an interesting fact that Doyle's *Punch* cover design remained in constant use until the 1950s, over a hundred years after it was first created.

Richard Doyle was one of the most talented of fairy illustrators. A natural doodler with an equally natural talent for composition, he worked best in miniature, with a fine quill pen and chinese ink, occasionally on lithographic stone, or etched plates. He found difficulty drawing in pencil on wood blocks for the engraver and much of the original delicacy of his line was flattened by his engravers — even the expert Dalziel brothers. An original Doyle ink sketch of an animal, for example, could rival a Caldecott quick sketch; it is easy to see why young Beatrix Potter lamented Doyle's passing. He often created exclusively for children, whom he loved. They were delightful entertainments in which he tested out new drawings or tales on young audiences. His strengths as an artist were many: a gift for comic invention (De Quincey called him a 'genius', D'Orsay called his early work 'extraordinary'), a quick eye for detail and a disciplined pen. His weaknesses were a lack of academic training which spoiled his figure drawings, a tendency towards sketchiness which tried the patience of his engravers, an inability to diversify his talent for fantasy, and an unfortunate lackadaisical manner which undermined his work and left it uneven. From the start he had wanted to become a history painter of large canvases which would earn him fame and fortune; in the end he settled for drawing parodies of his ambition, and delightful works of enviable fantasies.

And yet Richard Doyle's books and fairy paintings have more than mere 'period interest'. Their delicate inventiveness rival some of the best works of Cruikshank, Maclise or Brooke. His *Punch* cartoons and borders rival the best of Tenniel for sheer invention: it is sad to recall how Lewis Carroll abandoned a plan for a Doyle-illustrated *Through the Looking-Glass* — it would have been a delight. In this, the centenary year of Doyle's death, the works assembled in this exhibition, and my biography (the first to be published), set out to give the best of Richard Doyle's work and to point out how very good he was as a draughtsman and fairy painter. As a fantasist and social observer he was clearly: 'The Wizard and the Swell'.

RE

satirical drawings to McLean the printseller, who urged him to publish them. John Doyle had arrived on the political scene at a moment when for the first time in a century of caricature there was no one specifically political caricaturist of major stature, for Gillray had died in 1815, and Cruikshank, his successor had turned from radical protest to illustration.

Unlike the work of his predecessors, John Doyle's caricatures were drawn, not with the etching needle, but with chalk on stone in the new medium of lithography, a method particularly suited to his great gifts of capturing subtle nuances of facial expression and gesture in action or under stress of emotion. From the first the success of his caricatures was so marked that he decided in 1829 to issue them as a numbered series which continued for 22 years until 1851, the total number of lithographs being 917.

John Doyle had no party attachments and commented on political life and its personalities with the cool and objective detachment of an amused spectator. He was able to maintain this role as for many years he successfully concealed his identity under the cryptic initial letters HB, formed by repeating his own initials JD one above the other $\frac{JD}{JD}$, so as to look like HB. At the height of their fame the identity of the artist remained a mystery, as a letter of July 1831 which Macaulay wrote to his sister describing a visit to the Prime Minister in Downing Street reveals:— 'The servant told me that Lord Grey was still at the Lords. I sat down and turned over two large portfolios of political caricatures. Earl Grey's face was on every print. I was very much diverted. I had seen some of them before; but many were new to me and their merit is extraordinary. They were the caricatures of that remarkable artist who calls himself H.B.'

All commentators on his work have singled out John Doyle's decorum and restraint, Trevelyan in particular praising him for the transition he effected between the brutality of previous caricature and the more humane and decent ethos of the political warfare of the Victorian era. Thackeray wrote in 1840:—'You never hear any laughing at H.B.; his pictures are a deal too genteel for that — polite points of wit, which strike one as exceedingly clever and pretty, and cause one to smile in a quiet gentlemanlike kind of way'. While these comments are valid, it is perhaps worth remembering that John Doyle was aiming his work, not at the mass readership of a magazine, but at a small, sophisticated public who bought the 'H.B.' caricatures as they came out, three or four at a time, at intervals of about a month. He certainly never made the mistake of underestimating the intelligence of his audience. His compositional method was to transpose a current political event into the context of a well known literary or artistic incident, sometimes with devastating satiric effect — provided the reader knew the allusion. His caricatures were heavily laden with allusions to classical literature, the Bible, Shakespeare, Cervantes, and painting and sculpture — both 'Old Masters' and contemporary work. Anthropomorphising Landseer's works was a favourite device, used on no less than nine occasions.

As G.M. Trevelyan remarked in his *The Seven Years of William IV* 'John Doyle deserves to be better remembered than he is; not only as the father of Dicky Doyle but as an artist who has left to posterity a lively, exact and moving record of the leading public figures in a great period of our domestic history'. Born in Dublin in 1797 he entered the drawing school of the Dublin Society, and studied for a time with John Comerford, the miniature painter. This training as a miniaturist rigorously developed his powers of exact observation and delineation of facial expression in a way which was to prove of great value to him in his later career as a portrait caricaturist. But his early reputation was made as a sporting painter, specialising in individual portraits of horses, of which he exhibited 19 examples in Dublin exhibitions before leaving for London in 1821. In London he at first attempted to establish himself as a portrait and miniature painter, but in 1827 found his true role as a political caricaturist, beginning by showing a few

The sheer range of his literary and artistic knowledge was remarkable, and this knowledge, and thorough practical training in the arts, was to be passed on to his children, with some very remarkable results.

In 1851, the year of that watershed of the Victorian era the Great Exhibition, the HB series ceased. John Doyle was to live on in retirement for another 17 years, dying on 2nd January, 1868. Popular humorous journals like *Punch* and *Fun* had superseded his gentlemanly wit, which at its best, in the years prior to Queen Victoria's accession, had exactly caught the spirit of the time. It is appropriate to conclude the story of his career with the charming *Susannah and the Elders* of 1837, depicting the young Queen riding between Lord Melbourne, her Prime Minister on her right, and her Foreign Secretary, Lord Palmerston, on her left.

LL

PORTRAITS OF JOHN DOYLE 1797-1868

1. Bust — plaster cast by Christopher Moore (1790-1863)
Height
Lent by Lady Bromet, D.B.E.
A plaster cast of the marble bust of John Doyle exhibited at the Royal Academy 1850 (1369). The sculptor Christopher Moore and John Doyle seem to have been close friends, since there is a portrait of Moore by John Doyle in the National Gallery of Ireland, Dublin.

2. Portrait by Henry Edward Doyle (1827-1892)
Coloured chalks on brown paper 57.5 x 45.6 cms.
Lent by the National Portrait Gallery to whom it was presented by Sir Arthur Conan Doyle in 1926

3. Portrait drawing by George Dunlop Leslie (1835-1921)
Signed and dated 1856.
Inscribed Pinxt 1856
Pen and ink 15.2 x 12 cms.
Lent by Brigadier J.R.I.Doyle, O.B.E.

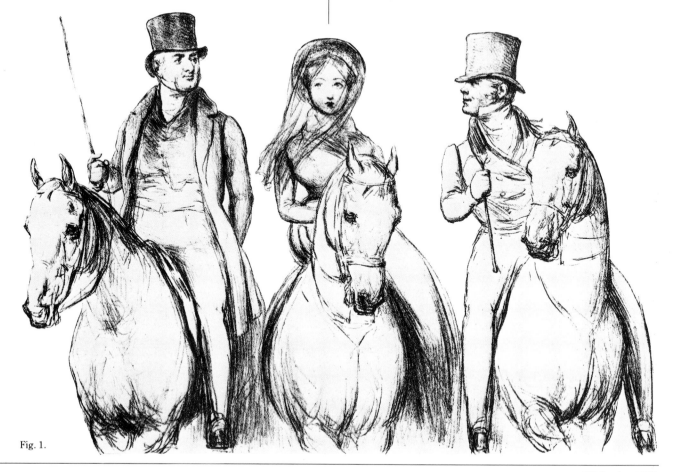

Fig. 1.

4. Le Mort. No 40 of HB's **Political Sketches.**
Caricature of George IV, the Marchioness of Conyngham and the Earl of Eldon, mourning the death of a pet giraffe, presented to the King with two Nubian attendants by the Pasha of Egypt on 13th August, 1827; the giraffe, stabled in Windsor Great Park, died two years later. Lord Eldon's presence, playing a lament 'The Blue Bells of Scotland' on the bagpipes, is an allusion to his frequent visits to Windsor, seeking audience with the King to obtain favours.
Published by T.McLean, 26, Haymarket. Aug 11, 1829.
Lithograph, coloured by hand 28 x 37.8 cms. E 890 − 1970.
John Doyle's more popular **Political Sketches** were often hand coloured, as in this example. The giraffe, a boon to caricaturists, and two other giraffes, also presented in 1827 to the King of France and Emperor of Austria, will be commemorated in an exhibition to be held at the Chateau de Sceaux from 18th April to 15th July, 1984.

5. A Great Actor Rehearsing his Part.
William IV preparing to address both Houses of Parliament. HB sketches No 299.
Published by Thos M'lean, Haymarket, London. January 28, 1834.
Lithograph 33.7 x 23.8 cms. E 806 − 1968.
Though eccentric, undignified and sometimes foolish, William, 'the Sailor King' was good natured, simple and fond of popularity. He had few political ideas, but gave real confidence and support to Wellington and then to Gray, successfully adapting the role of Monarch to the new situation created by the controversial effects of the Reform Bill of 1832 which inaugurated his reign. John Doyle, in this, and many other caricatures, gives us a vivid portrayal of the King's baffled and somewhat bovine face under stress.
Both the above lent by the Victoria and Albert Museum.

6. Tam O'Shanter
Watercolour 26.2 x 38.4 cms.
A swift wash drawing by John Doyle for No 644 of his **Political Sketches,** based on Robert Burns poem. Doyle would have copied the drawing directly on to the lithographic stone using a mirror to reverse the image. This is one of the few examples of his work for the series not in the British Museum, which has over 600 drawings by John Doyle.

7. Tam O'Shanter. HB sketches No 644.
Published by Thos M'Lean, Haymarket, London
Lithograph 23.8 x 37.4 cms.
Lettered: − 'The Carlin caught her by the Rump
And left poor Maggie scarce a stump'.
John Doyle depicts Lord John Russell, the Prime Minister, as Tam. He is mounted on his horse Maggie, which bears the head of Daniel O'Connell. The horses tail is being clutched by the witch Cuttie Sark, a reference to the defection of Government supporters to the opposition cause over the passage of a controversial Irish Bill. It is interesting in this caricature to see John Doyle's imaginative use of a supernatural theme of a type to prove so attractive to his sons Richard and Charles.
Both the above lent by Alan Cuthbertson.

8. A Letter to Lord John Russell, on the Future Location of The National Gallery and Royal Academy by John Doyle, 1850. In this letter, his contribution to a lively public debate on this issue, John Doyle warmly advocates South Kensington as a home for both institutions.
Lent by the Victoria and Albert Museum.

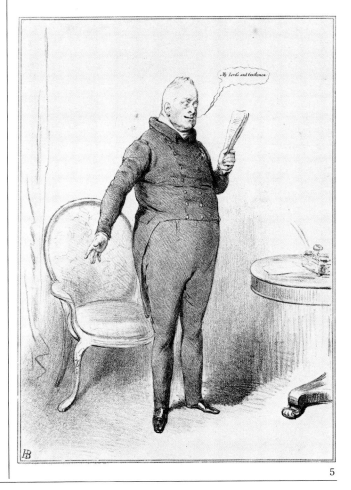

5

THE Doyles were an extremely close knit family, particularly after the tragically premature death of John Doyle's wife Marianna in 1832. They lived in London, at 17, Cambridge Terrace, just off the Edgware Road, in a house which still survives, although the numbering has changed. None of the children attended school, a tutor, Mr Street, calling several times a week. John Doyle's income was a modest one, but the house was shared with Marianna's brother Michael Conan, an art critic, and his wife. Fifty years later in 1885 Charles Altamont Doyle, writing in his diary at Sunnyside, Montrose Royal Lunatic Asylum, recalled the way in which Sundays were spent, after looking through a copy of the facsimile of Richard's *Journal of 1840*:— 'A propos of 'Dick's Journal' — Copy of which Dr Howden has kindly lent me — I should like to mention one point in the inner life of the Doyle Family when this Journal was written — It is this — On Sunday the Day was observed by all the Children — Great and Small — Annette — James, Dick, Henry, Frank, Adelaide and myself, going to the Mass, celebrated at the French Chapel at 8 o'clock A.M. This in winter meant going from Cambridge Terrace, up Edgware Road — down George Street a couple of miles — often in the dark, and getting home to breakfast at 10 — The after day was spent in perfect quiet till 8 in the evening when the Camphore Light and Mole Candles were lit in the Drawing Room, and guests began to arrive, often comprising the most distinguished Literary and Artistic Men of London and Foreigners — Thackeray and Lover — Rothwell and Moor/ Sculptor amongst others — Most delicious Music was discoursed by Annette on the Piano — and James on the Violincello till about 10 when the Supper Tray was laid — generally just Cold Meats and Salad, followed by Punch — We Boys all retired when this appeared — but up Stairs in Bed I have often listened to indications of most delightful Conversation till 1 or 2.'

This vivid verbal picture of the happy family life at Cambridge Terrace is brilliantly amplified and visually recorded in the pages of *Dick's Journal of 1840* (18). Richard's and Charles's careers form the main theme of this exhibition, but it is necessary at this point to record the careers of the other members of the family.

James William Edmund Doyle (1822-1892) the oldest son was known as 'The Priest' and was the scholar of the family, fascinated with history from a very early age. He commenced his career as a painter, (9) but soon turned to the pursuit of historical studies, particularly heraldry and genealogy. His most notable book was *A Chronicle of England* 1864 with 81 coloured illustrations from his own drawings. But his life long labour was the production of *The Historical Baronage of England,* published in three volumes in 1886, with 1,000 line illustrations. Although it has become a standard work of reference for the College of Arms it proved a financial failure. Other worldly and retiring he was only two years older than Richard, and his knowledge must surely have helped to influence his brother's *Comic Histories.*

Henry Edward Doyle (1827-1892) R.H.A., C.B., was born, unlike the rest of the children in Dublin, and was always to remain the closest of the family to their Irish roots. After art training in Dublin, he, like Richard worked briefly for *Punch* in 1844, and later from 1867 to 1869 drew cartoons for the rival publication *Fun,* which he signed with a *'Hen'* or *'Fusbos'.* A devout Catholic, he was drawn to religious painting as a vocation, and executed some frescos for the Chapel of the Dominican Convent at Cabra, near Dublin in 1864, and a *Last Judgement* at the Roman Catholic Church at Lancaster. He also painted portraits, and the National Gallery at Dublin has an oil portrait of Cardinal Wiseman and a pencil portrait of John Ruskin by him, as well as the portrait of his brother Richard (14).

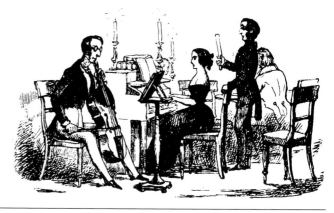

In 1869 he became Director of the National Gallery of Ireland and held the post until his death. His most notable acquisitions for the Gallery was Rembrandt's *Sleeping Shepherds,* and works by Fra Angelico, Bellini, and Correggio, but he also acquired fine examples of the work of Reynolds and Gainsborough and Richard Wilson, whose landscapes were then not greatly appreciated. In 1886 at the Christies sale he acquired a fine collection of his brother Richard's work, notably *The Triumphant Entry — A fairy pageant* (129).

Sadly little is known of the two daughters of this talented family. Adelaide, the youngest, died of consumption in 1844, as did Francis, the third son. She seems to have had remarkable literary abilities, as can be seen in the facsimile of her version of *Beauty and the Beast* illustrated by Richard, and her translation of Victor Hugo's romance *Le Beau Pecopin et la Belle Bauldor* from *Le Rhin,* 1842. Annette, who never married, was in later life to act as Richard's housekeeper.

Ironically it was Charles, the youngest, weakest, and yet in some ways the most enigmatic member of the family, who was to carry on the Doyle name, all the others dying without issue.

LL

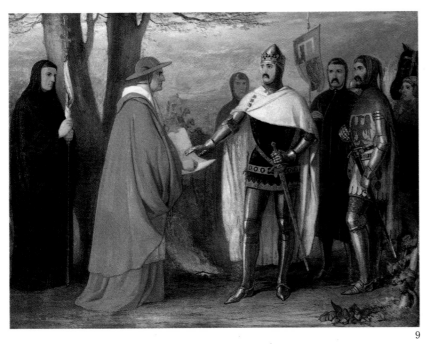

9

THE FAMILY

JAMES WILLIAM EDMUND DOYLE (1822-1892)

9. The Black Prince on the Eve of the Battle of Poitiers.
Outnumbered by the French army, the Black Prince agrees to parley with Cardinal Talleyrand of Périgord, but refuses to surrender with a hundred of his Knights. The time taken up by this negotiation is used to strengthen the English position in readiness for the Battle of Poitiers, where the French are utterly defeated and their King taken prisoner.
Signed and dated 1849.
Oil on canvas 49.2 x 67.3 cms.
Lent by Stephen Wildman.

10. A Chronicle of England, 1864.
Two copies, one lent by the Victoria and Albert Museum, the other by Michael Heseltine.

11. The Baronage of England, 1886.
Victoria and Albert Museum.

**12. A group of armed men surround a Knight Kneeling before a King.
Pen, ink and watercolour 21.2 x 24.2 cms.
Lent by the Victoria and Albert Museum. E 364 — 1948.

**13. William Tell.
Watercolour 7.5 x 12.7 cms.
Lent by Brigadier J.R.I. Doyle, O.B.E.
A manuscript version of William Tell with two illustrations, paper watermarked 1841, is in a private collection.

HENRY EDWARD DOYLE R.H.A., C.B. (1827-1892)

**14. Portrait of Richard Doyle.
Oil on canvas.
Lent by the National Gallery of Ireland, Dublin.

**15. Catalogue of the collections of the National Gallery of Ireland, Dublin.
Lent by the Victoria and Albert Museum Library.

ADELAIDE DOYLE

16. Facsimile of **Beauty and the Beast, circa 1842, published 1973.

THE DOYLE BROTHERS

17. The Lover's Stratagem by Heinrich Zschokke, 1849.
Illustrated by James, Richard and Henry Doyle.

18. Dick Doyle's Journal, 1840.
The original manuscript of 156 pages 18.3 x 23.4 cms.
Lent by the British Museum.

DICK Doyle never really abandoned his childhood preoccupations with comic versions of historical, romantic or adventure themes. Those early book projects done for his father were the seeds of his comic genius, and much care was taken to satisfy the immensely high standards set by his father for their completion. His tutor taught him to study history and the classics, subjects from which he borrowed heavily for his books, like the first, *Homer for the Holidays*. He collaborated with his elder brother James on his first published designs for a set of comic envelopes, devised from topical and fantasy subjects. He chose romantic tales of chivalry, pored over Walter Scott as well as strong narrative poetry like Byron's 'The Corsair' — his favourite poem. With his sister Adelaide as translator, he illustrated a version of Victor Hugo's stirring romance, 'Le Beau Pécopin' from *Le Rhin*, but this, typically, remained unfinished. His boyhood love of legends led to experiments with dragons and monsters, culminating in the *Jack and the Giant Killer* drawings, with comic borders and elongated figures refiguring his *Punch* successes.

RE

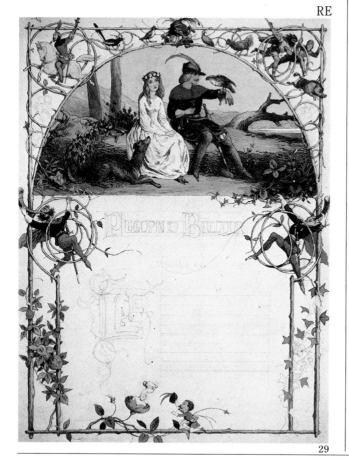

29

JUVENILE WORKS

19. The Fetch.
Signed R.Doyle.
Pen and ink 18 x 22 cms. E 385 — 1948.

20. Ah! La petite Coquette.
Signed R.Doyle.
Pen and ink 17.3 x 16.2 cms. E 386 — 1948.
Two youthful drawings dating from the mid 1830's.
Both lent by the Victoria and Albert Museum.

21. Homer for the Holidays. 1836 published 1887.
Lent by Michael Heseltine.

22. A selection from ten pictorial envelopes published in 1840 by S. Fores.
Lent by David Temperley.

23. Bluebeard.
Inscribed **No 2. Fatima going to the Blue Chamber** and signed RD (monogram).
Pencil and wash heightened with white 21.3 x 23.8 cms.
E 383 — 1948.

24. Bluebeard.
Inscribed **No 4. Fatima's horror at seeing the heads of Bluebeard's murdered wives in the Blue Chamber** and signed RD (monogram).
Pencil and wash heightened with white 23 x 25.2 cms.
E 384 — 1948.
Two drawings illustrating the story of **Bluebeard** dating from circa 1840.
Both lent by the Victoria and Albert Museum.

25. Dick Doyle's **Journal of 1840**, facsimile, published in 1885.

26. Grand Historical, Allegorical, Classical and Comical Procession, 1842.
Lent by Michael Heseltine.

27. Byron's poem **The Corsair** illustrated by Dick Doyle before his 16th year, bound into an album.
Size of sheets 25.2 x 20.1 cms.
Lent by the Syndics of the Fitzwilliam Museum.

28. A page from a transcription of Victor Hugo's romance **Le Beau Pécopin et la Belle Bauldor**, from **Le Rhin**, 1842.
Pen, ink, pencil and watercolour. 27.2 x 21.4 cms.
Victoria and Albert Museum E 465 — 1975.

29. The first page of text from **Le Beau Pécopin et la Belle Bauldor**, from Le Rhin, 1842.
Pen, ink, pencil and watercolour.
This page and the following six drawings were made to illustrate a version of Hugo's story translated into English by Richard's sister Adelaide.
All lent by Michael Heseltine.

a. The Fall from the Minaret.
Watercolour 21.5 x 15.7 cms.

b. A Falconry Party — The Departure.
Watercolour 8 x 16.7 cms.

DOYLE called them 'his Nonsense' and described in a letter to his father (September 1843, Pierpont Morgan Library) how he gathered inspiration and confidence drawing in the books in 'a style of subject which cannot be described and is called "Nonsense"'. His father apparently tried to steer him away from such frivolous exercises, for Dick was often apologising and promised to attempt "something serious next'. But in the end he always returned to the sketchbooks for relief from taxing projects, even admitting to his father he preferred 'a rather large and coloured drawing of some subject from my "Nonsense" to be going on with'.

RE

c. A Falconry Party — The Kill.
Watercolour 10.9 x 21.7 cms.

d. An Archery Tournament.
Watercolour 7.3 x 16.1 cms.

e. Border.
Watercolour 24.3 x 19.1 cms.

f. Lovers.
Watercolour 5.2 x 16.6 cms.

g. Falconer and Knight.
4.4 x 17 cms.

Fig. 2 A Lion of Paris by Grandville.

NONSENSE SKETCHBOOKS

30. Frontispiece to **A Book full of Nonsense by Dick Kitcat. 1842.**
Pen and ink 25.2 x 19.8 cms.
Victoria and Albert Museum E 878 — 1911.
Self portrait of Richard Doyle as 'Dick Kitcat' at the easel sketching a society 'lion', derived from Grandville—Jean Isidore Gérard (1803-1847). The theme of an artist at the easel was often used by Doyle, notably in one version of the famous **Punch** cover.

31. The Trojan Horse.
Pen and ink 25.2 x 19.8 cms.
Victoria and Albert Museum E 879 — 1911.
Possibly a projected drawing for an **Illustrated Homer** which was never published, similar to **Homer for the Holidays**, 1836.

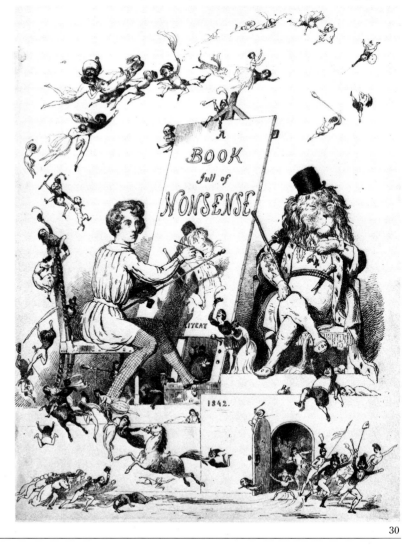

30

32. Frontispiece to a **Book Fool of Nonsense** (sic).
Pen and ink 25.2 x 19.8 cms.
Victoria and Albert Museum E 458 — 1976.
A wizard surrounded by fairies, depicted in poses derived from
lithographs of the Romantic Ballet.

33. Giant.
Pen and ink 25.2 x 19.8 cms.
Victoria and Albert Museum E 458 — 1976.
An early version with human figures of the Giant in **Jack and
the Giants** 1850-1851. When published, at the insistence of the
publisher, animals were substituted for the human figures the
giant is carrying.

34. A Bear Pit.
Pen and ink 25.2 x 19.8 cms.
Victoria and Albert Museum E 458 — 1976.
Probably inspired by one of Doyle's frequent visits to the Zoo.

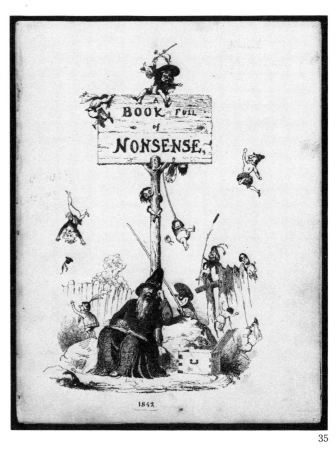

35

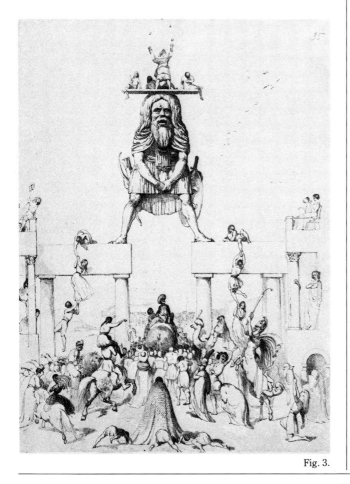

Fig. 3.

36

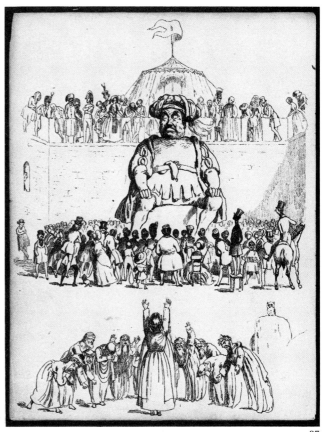

37

35. Frontispiece to **A Book of Nonsense.**
Pen and ink 25.2 x 19.8 cms.
Victoria and Albert Museum E 459 — 1976.
A Wizard seated under a signboard.

36. Comic figures.
Pen and ink 25.2 x 19.8 cms.
Victoria and Albert Museum E 459 — 1976.
Comic figures, closely related to those appearing in **Scenes from English History,** composed with the collaboration of his brother James in 1840-1842, but published in 1886. At the bottom of the sheet are fantastic anthropomorphic figures which are derived from Grandville's **Scènes de la Vie Privée et Publique des Animaux.** Paris 1842.

37. A Giant watched by a crowd.
Pen and ink 25.2 x 19.8 cms.
Victoria and Albert Museum E 459 — 1976.
Possibly meant to represent Rabelais's Gargantua being admired by the Parisians.

38. A double page in a fantasy sketchbook of paper watermarked 1842.
Pen, ink and pencil 29.1 x 24 cms.
Victoria and Albert Museum E 460 — 1976.
The full page drawing on the left is a rejected design for a **A Midsummer Knight's Dream** published in 1848 in **Rejected Cartoons.** A watercolour, derived from the same composition, is in the Huntingdon Art Gallery, San Marino, California.

39. A double page in a fantasy sketchbook of paper watermarked 1842.
Pen, ink and pencil.
Victoria and Albert Museum E 461 — 1976.
An elaborate composition showing Doyle's delight in inter-relating different layers of a fantastic landscape with chains of subtly interlinked figures.

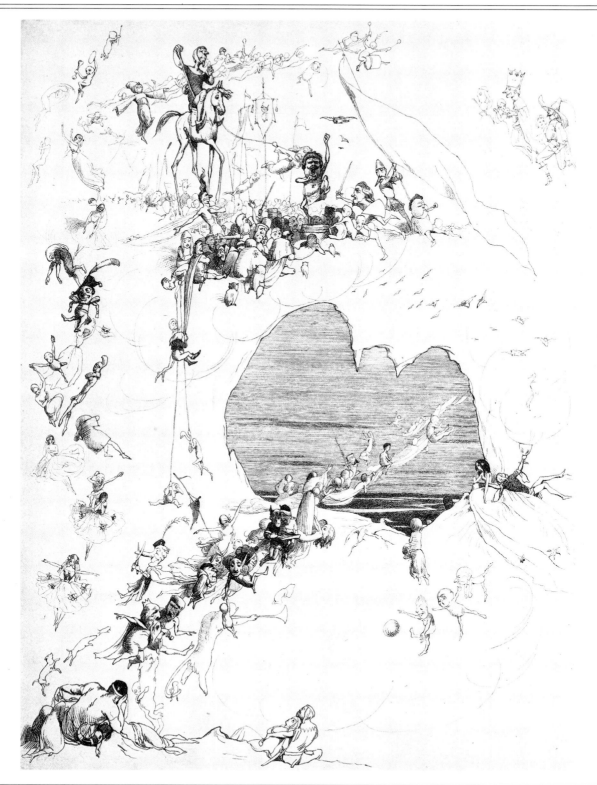

DICK Doyle spent his childhood immersed in the past. He learned history from French and English textbooks and borrowed liberally from their accounts of famous battles and royal intrigues for drawings and paintings to please his father. Unlike his early collaborator, his brother James — the future historian of the family for whom facts and dates were essential — Dick distrusted textbook history. He preferred his own oblique view of events, the whimsical, often irreverent approach he adopted in his early books, like *The Tournament*. Here was his hilarious version of the disastrous Eglinton Tournament, 1839, which had been heralded as the supreme example of the revivalry of chivalry until, much to its critics' delight, it had been turned into a travesty by three days of torrential rain — as Dick's drawings indicate. His *Scenes from English History*, again a collaboration with James, who quickly devised the text, was a quirky, exaggerated piece of historical nonsense; a schoolboy's fantasy enhanced by accurate detail in costumes and armour. His *Grand Historical Classical and Comical Procession* was more pleasing as a piece of pure Doyle whimsy, a delightful procession book drawn from his imagination of persons 'Ancient Modern and Unknown'. Such works fed his ambition to become a famous history painter and he nurtured his plan by constant visits to the London galleries. The Westminster Hall cartoon competition provided a stirring example of what could be achieved in its massive display of cartoons for fresco decorations to the Houses of Parliament. Dick was a frequent visitor to the exhibition and afterwards used it to inspire his again oblique view of the proceedings: *Selections from the Rejected Cartoons,* which parodied the winning entries and adopted the tone of a rejected exhibitor. Unfortunately most of his historical, as well as his juvenile work, remained unpublished until after his death.

RE

COMIC HISTORIES

40. The Tournament, or The Days of Chivalry Revived. 1840.
Lent by Michael Heseltine.

41. Caxton presenting a copy of his first book to Edward IV.(?)
Watercolour 29.4 x 35.5 cms.
Possibly a comic version of a subject painted by James.
Lent by Michael Heseltine.

42. Henry VIII and Catherine Parr.
Watercolour 13.9 x 18.9 cms.
Lent by Lady Bromet, D.B.E.

43. Elizabeth and Essex.
Watercolour 13.9 x 18.9 cms.
Lent by Lady Bromet, D.B.E.

44. Three pen and ink drawings for an initial, and two illustrations for the original manuscript version of the **Comic History.**

45. Scenes from English History, 1840. Published 1886.

46. Selections from the Rejected Cartoons. 1848.
Lent by Michael Heseltine.

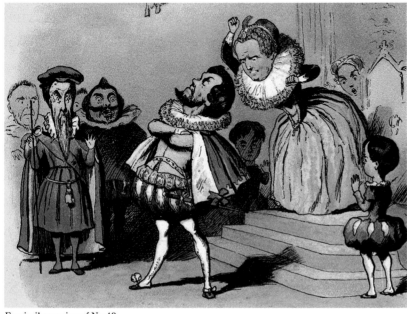

Facsimile version of No 43.

51

52. Parliament Street
Pen and ink 11.6 x 17.7 cms.
Lent by Alan Cuthbertson.
A preparatory drawing for a caricature in **Punch**. Mr Punch appears in the centre of a traffic jam representing Government and Opposition.

53. Punch's Vision of Stratford-on-Avon.
Pen and ink 11.8 x 16.8 cms.
Drawing for caricature published on November 13th, 1847, page 184.

54. Punch in Parliament
Pen and ink 11.1 x 8.8 cms.
Drawing depicting Punch arm in arm with Sir Robert Peel and Lord John Russell. Published on November 27th, 1847, page 204.

55. Punch telling the Members to go about their Business.
Pen and ink 16.5 x 22.3 cms.
An irate Punch on the floor of the House of Commons. Published on September 9th, 1848, page 100.

The above three items lent by Michael Heseltine.

56. The Punch Almanach.
Special hand coloured edition 1848.

57. Gilbert A Becket Almanach of the Month 1846.

58. Ye Manners and Customs of Ye Englyshe in 1849. No 8
Ye Commons Resolved into a Committee of ye Whole House Sir Robert Peel speaks, while next to him, on the front bench, Disraeli listens.

59. Ye Manners and Customs of Ye Englyshe in 1849. No 12
A View of Epsom Downs on Ye Derbye Daye.
Nine years before W.P.Frith's vast canvas **Derby Day** was exhibited at the Royal Academy in 1858, Doyle's amusing drawing includes many of the same elements in this crowded composition: Gypsy fortune tellers, thimble rigging — a game in which the victim tries to decide which of three thimbles conceals a pea, entertainers, and society 'swells' picnicing.

The above four items lent by Michael Heseltine.

60. Door Stop.
Lead 31.5 cms.
Lent by Lionel Lambourne.
Doyle's design for the **Punch** achieved widespread fame as an advertising image, and was reproduced on ceramics, textiles, and even as a metal doorstop.

61. The Punch Tree.
Dicky Doyle loved trees, particularly those with old gnarled, twiggy branches and twisted roots. They appear again and again in his work, both as compositional frameworks for his larger fairy paintings, and in the form of initial letters in **The Newcomes** and **Punch**. During the six years in which he drew every week for **Punch** he designed dozens of these delightful letters, and this **Punch** tree has been devoted to a display of this enjoyable aspect of his work.

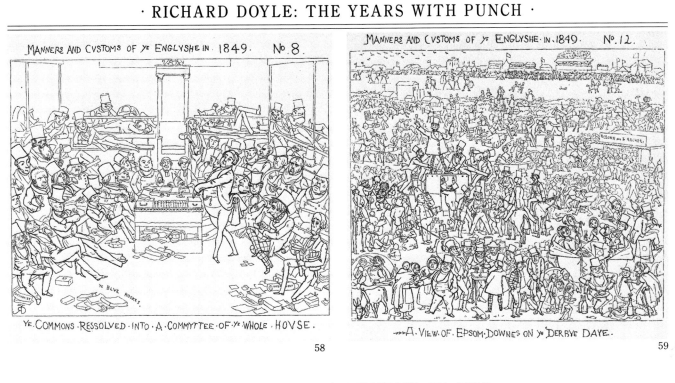

58

59

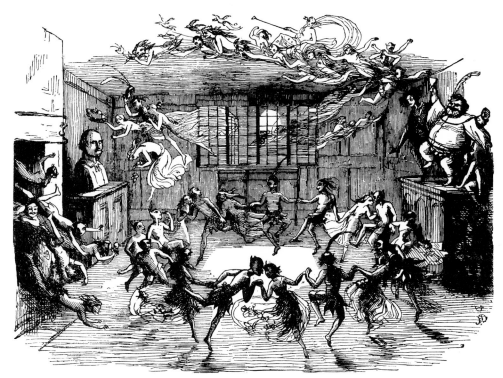

PUNCH'S VISION AT STRATFORD-ON-AVON.

THE NIGHT OF THE SIXTEENTH OF SEPTEMBER.

Engraved version of No 53.

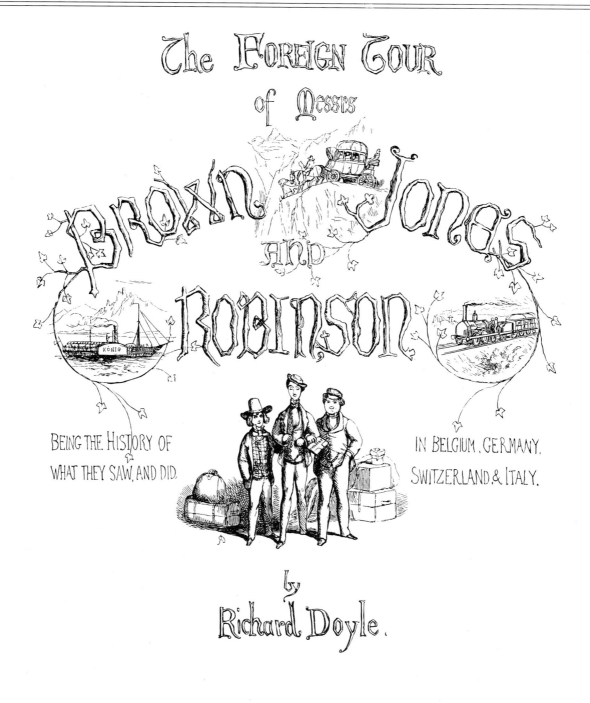

The Foreign Tour

of Messrs

Brown, Jones

and

Robinson

Being the History of
What they saw, and did.

In Belgium, Germany,
Switzerland & Italy.

by
Richard Doyle.

London. Bradbury & Evans. Whitefriars. 1854.

THE FOREIGN TOUR OF MESSRS. BROWN, JONES and ROBINSON

Being the History of what they saw, and did in Belgium, Germany, Switzerland and Italy. London, 1854

THE hilarious comic trio were Doyle's creations and first appeared in his last issues of *Punch* in 1850. They proved popular enough for him to turn their comic antics as British tourists on the continent, into a hugely successful book, *The Foreign Tour of Messrs. Brown, Jones and Robinson,* being the history of what they saw and did in Belgium, Germany, Switzerland and Italy, 1854. The three young bachelors were immediately taken up by the English and later American and French public as typifying the benign, head-strong and accident-prone elements in British tourists while the observant Brown, with sketchpad always to the ready, captured the less agreeable elements of snobbish, chauvinism and what critics called 'ungentlemanly behavoiur'. The original exploits of the three characters were derived from Doyle's own experiences in society. Brown is a clear self-portrait of Doyle himself; Jones is modelled after the wit and *Punch* writer Tom Taylor; Robinson after the uninhibited *Punch* colleague Watts Phillips. The Foreign Tour was based upon the three men's actual journey to the continent in 1850, and according to Doyle's letters home to his family, much was retained from his original impressions during this his first and only trip abroad. It was this fidelity to actual life which endeared the trio to a larger audience until Brown, Jones and Robinson became household names, representatives of the aspiring young middle-class swells who attempted to take their places in society, however difficult it proved. For over twenty years the Foreign Tour delighted readers and remained in print, while pirated editions appeared in America, alongside parodies like *The American Tour of Messrs. Brown, Jones and Robinson,* being the history of what they saw and did in the US, Canada, and Cuba, by Toby. In England by the 1880's *The Foreign Tour of the Misses (sic) Brown, Jones and Robinson,* being a history of what they saw and did at Biarritz, had appeared; Trollope modelled a *Cornhill* serial after the trio, and even the staunch Matthew Arnold recalled how his nine year old son, Tom, could be heard 'in the next room talking to his mama about "Brown, Jones and Robinson"'.

All drawings in this section RE
lent by M. Heseltine.
Proofs: Victoria and Albert Museum.

62. The Arrival at Cologne. Travellers passing their examination. In the foreground is Jones's portmanteau undergoing the 'ordeal by touch'.
Wood engraved proof.

63. The real Eau de Cologne, and its effects upon the noses of three illustrious personages.
Wood engraved proof.

64. They 'do' Cologne Cathedral.
Wood engraved proof.

65. The Railway from Cologne to Bonn- B.J. and R., 'Just in Time'.
Wood engraved proof.

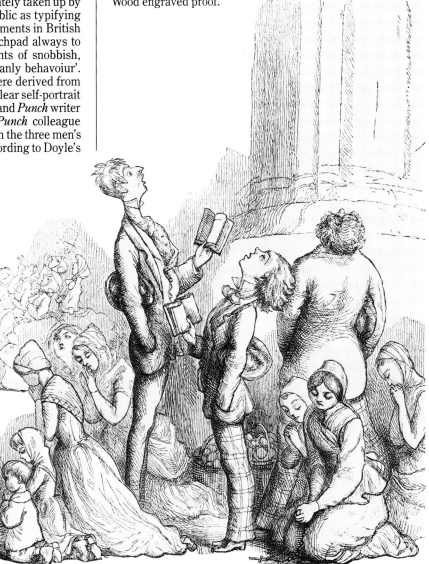

64

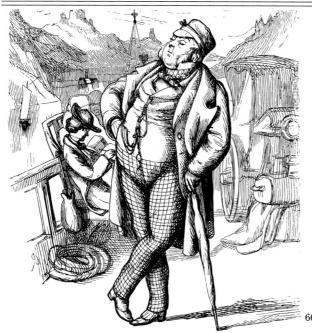

66

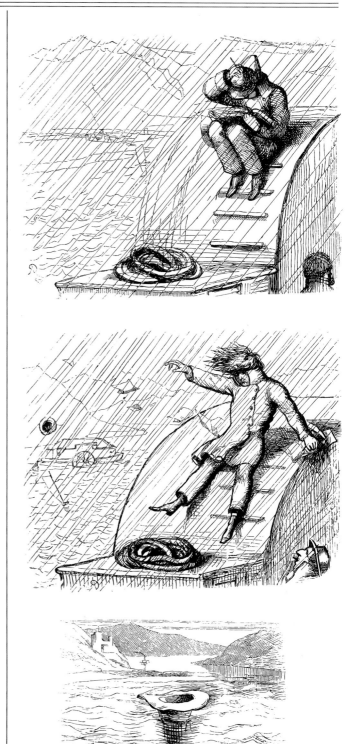

68

66. The Rhine. The Great Briton. As he stood contemplating the Rhine-land, wondering if it would be possible to live in that country; and considering, (supposing he had one of those castles now) how many thousands a-year one could do it with. The scenery would do; and with English Institutions it might be made a good thing of. N.B. He little thinks what Brown is doing. Wood engraved proof.

67. The Rhine. Even the Nun was not safe from Brown. He is here seen taking her off, in a rapid act of sketching. Wood engraved proof.

68. The Rhine. Brown, with noble perseverance, sits upon the paddle box, regardless of the storm, and sketches the castles and towns, as the steam boat passes them. —till in a moment of grief his hat and several sketches were carried off for ever; and then he thought it time to go below. Photograph.

69. Small sketches (various sizes) (a) (b) Brown on the puddle box (c) Brown's hat blows away (d) Brown's hat in the Rhine (e) Brown's hat (photograph).

70. Sketches of (a) Robinson's luggage (b) his portmanteau (c) Photograph of:— How Robinson's favourite portmanteau, which he had forgotten to lock, was dropped accidentally by a porter, while conveying it to the omnibus.

71. Frankfort. How they visited a 'quarter' of the city of Frankfort, and what they saw there! Photograph. The Judengasse at Frankfurt, where, at the time of Doyle's visit the formidable mother of the four famous Rothschild banker brothers still lived.

72. Preliminary drawing for the above scene.

73. Heidelberg (a) Meeting by Moonlight (photograph) (b) Preliminary drawing.

74. Breakfast at Bellinzona. It was their first day in Italy, and how they did enjoy it!
Wood engraved proof.

75. Italian Lakes Evening on the Lago Maggiore.
Wood engraved proof.

76. Market Scene.
A drawing not used, but related to this section of the book.

77. Pleasant!
Preliminary drawing.

78. Pleasant!
Wood engraved proof.

79. Milan—the Barber's Shop.
(a) Wood engraved proof.
(b) Preliminary drawing.

80. Venice. Robinson (solo)—'I stood in Venice,' etc.; Jones and Robinson, having heard something like it before, have walked on a little way. **Reflection made by Brown.** Why do people when repeating poetry always look unhappy?
Wood engraved proof.

81. Small drawings of Jones' and Robinson's days (a) (b) (c) (d).

82. The Passport Inspector.
(a) Photograph 'Passports!' — 'That's the sixth time we have been woke up', groaned Robinson.
(b) Preliminary drawing.

83. Brown, Jones and Robinson in the Highlands.
Proof for the unpublished sequel to The Foreign Tour of Brown, Jones and Robinson.

84. A drawing of dancing Scotsmen, possibly made in connection with Brown, Jones and Robinson in the Highlands.
Pen and ink.
Lent by David Fuller.

83

75

WILLIAM Makepeace Thackeray was an early friend of Doyle's, for whom Dick had secured work reviewing Irish books for his uncle's paper *The Morning Chronicle,* following Thackeray's return from Ireland. They quickly became close friends and social companions, either sharing dinner parties and comparing notes about famous hostesses, or exploring 'Bohemia' together. When Doyle resigned from *Punch,* where Thackeray also contributed, his friend watched his future prospects with concern, and eventually commissioned Doyle illustrations to his *Rebecca and Rowena,* 1849-50, and later *The Newcomes,* 1853-55. Both proved a serious strain upon their friendship, especially *The Newcomes,* with its suggestive and painful reminders of Doyle's traumatic private affairs at the time. However the two men remained friends until Thackeray's death in 1863.

Charles Dickens was a childhood hero, whose stories Dick Doyle memorised and read in each instalment. They met and quickly became friends while Doyle was a *Punch* staff member, Dickens sharing friendships with many of the *Punch* staff. Doyle became a favourite guest at the Dickens home in Devonshire Terrace, and the famous author took his young friend 'into bohemia' where they explored the smoke-filled drinking establishments and even country inns which figured so strongly in Dickens's work. As a result, Doyle was asked to contribute to Dickens's annual Christmas books, and provided illustrations to three, sharing the task with other friends like Maclise, Leech and Stanfield.

As a result of his literary associations, Doyle consented to illustrate works by some of the period's most celebrated poets and prose writers. He generally adopted a fine etched-line style, used a classical line borrowed from Flaxaman as well as his father's political drawings. These first appeared as a large plate for the Art Union's *L'Allegro and Il Penseroso,* 1848, and as classical landscape vignettes and initials in Leigh Hunt's anthology of classical poetry and prose, *A Jar of Honey from Mount Hybla,* 1847. Doyle had learned to etch from John Leech, and provided five plates to Leech's commission, *The Fortunes of Hector O'Hallaron,* 1843, and later adopted the same clarity of line, without the atmosphere, in his drawings for wood-engravings to Frederick Locker's *Poems,* 1865.

RE

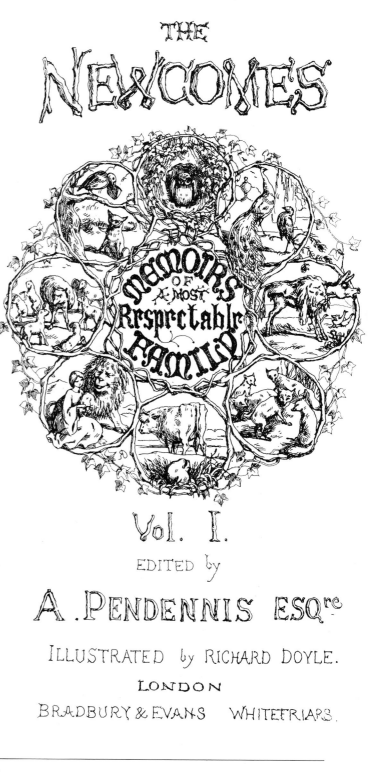

THE NEWCOMES

MEMOIRS OF A MOST Respectable FAMILY

Vol. I.

EDITED by

A. PENDENNIS ESQre

ILLUSTRATED by RICHARD DOYLE.

LONDON

BRADBURY & EVANS WHITEFRIARS.

LITERARY PARTNERSHIPS

85. William Makepeace Thackeray
Pencil 23.4 x 15.8 cms.
Lent by the British Museum 1886-6-19-7.

86. Six sketches on one mount.
John Forster 12.6 x 6.9 cms.
Charles Dickens and John Forster 6 x 6 cms.
Henry Cole 6.5 x 6.9 cms.
John Leech and
Tom Taylor 5 x 6.9 cms.
Mark Lemon as Robert Macaire 9.7 x 8.1 cms.
Douglas Jerrold, Charles Dickens
and John Forster 10 x 8.8 cms.
Lent by the British Museum
1886-9-19. 94.93.92.91.95.
Some delightfully vivacious sketches of some notable figures in Doyle's life.

87. Charles Dickens **The Chimes** 1845.

88. W.M. Thackeray **Rebecca and Rowena** 1850.

89. Drawing for **Rebecca and Rowena.**

90. W.M. Thackeray **The Newcomes** 1854/5.
The above four items lent by Michael Heseltine.

91. Original drawing for the Art Union's **L'Allegro and Il Penseroso,** 1848.
Pen, ink and pencil 16.9 x 12.7 cms.
Private Collection.

92. Leigh Hunt **A Jar of Honey from Mount Hybla,** 1847-48.

93. Drawing for an initial letter T for **A Jar of Honey from Mount Hybla** depicting a Knight in armour.

94. A Selection from the works of F. Locker, 1865.
Proof sheet of illustrations.
The above three items lent by Michael Heseltine.

95. A Japanese fan, 57.6 x 14.3 cms.
Lent by a grand-daughter of Anne Thackeray Ritchie. A Japanese fan, with the figures of two geisha and two attendants, to which Dicky Doyle has added an interpretation of Shakespeare's speech on the Seven Ages of Man in **As You Like It,** using Japanese figures. The fan is signed on the left EBJ with a small sprig of laurel leaves in what is apparently Edward Burne-Jones own hand. This remarkable fan is accompanied by a letter on the paper of The Athenaem Club, and addressed 'or 54 Clifton Gardens March 31st'72.

> Dear Miss Thackeray,
> It seems only fair that some time or other your long lost fan should be returned to its rightful owner, and it is herewith sent home with no end of the most abject apologies on account of the delay.
> You will see a scribble in one corner in the artist's early, or late, Japanese manner. It is intended to illustrate, remotely and after a fashion, the seven ages of Shakespeare.
> Most sincerely yours,
> Richard Doyle.

96. Calendar heading designs: Six Proofs
Victoria and Albert Museum
The Dalziel brothers secured this commission for Doyle, and it marked the first association between the artist and the engravers, who were to play a vital role in his post-Punch career. Doyle agreed to provide monthly calendar heading designs published in the **London Illustrated Almanack** c. 1850. They were wood engraved by major engravers of the day: W.J.Linton, Henry Vizetelly, the Dalziels and Edmund Evans. Doyle was offered a woefully small fee for his designs but the Dalziels refused to complete their work until Doyle was adequately paid. Doyle subsequently drew designs for the Almanack's publisher, the **Illustrated London News,** 1850-51.

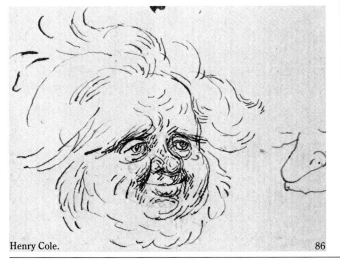

Henry Cole. 86

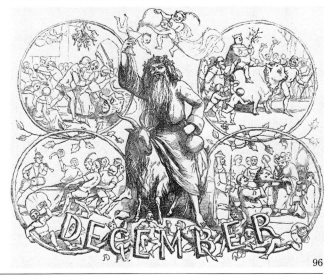

96

THERE can be little doubt that John Doyle's daily work as commentator on the transient political events of the 1830's was to prove influential on the formative years of all his sons, particularly Richard. The training in acute observation of the social scene revealed on every page of the 1840's journal was to continue to bear fruit throughout Richard's career. In his six years of work for *Punch* these skills can be seen to hold equal sway with the constant demand for fantastic initial letters, borders and humourous covers. But Punch was to see the initial runs of *Brown, Jones and Robinson,* and *Ye Manners and Customs of Ye English* which, some years later, were to attain the status of separate publication, as was his later work for Thackeray's *Cornhill; The Bird's Eye View of Society.*

All these works reveal Richard's immense appetite for crowd scenes at all levels of society, and his enjoyment of themes as diverse as audiences leaving the opera house, society soirees, low music halls, the race course, crowds lining a processional route, and the concert hall. His eye was everywhere, and this aspect of his work, although today less remembered than his fairy pictures, reveals his art at its best.

LL

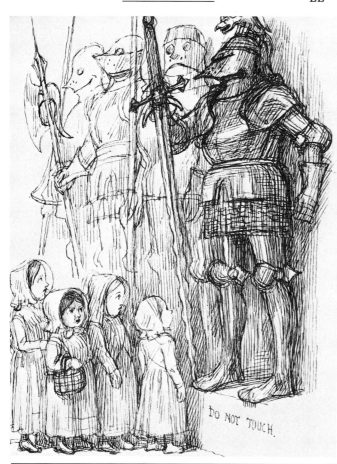

DRAWINGS OF THE SOCIAL SCENE

97. Sir Roger de Coverley.
Pen and ink 18.9 x 27.7 cms.
Lent by Alan Cuthbertson.

98. Departure from the Opera.
Pen, ink and pencil 11.4 x 20 cms.

99. Skating—possibly on the Serpentine.
Pen, ink & pencil 16.5 x 26.3 cms.

100. The Belle of the Ball.
10.5 x 15.8 cms.

101. Waiters at a Buffet.
Pen and ink 8.5 x 13.5 cms.

102. Jealousy.
Pen, ink and pencil 14 x 20.7 cms.
A young man reads at a table while nearby a young Adonis is surrounded by a circle of admiring ladies.

103. St. Valentine's Day?
Pen, ink and pencil 17.8 x 13.2 cms.
All the above works lent by Richard Dennis.

104. Epsom Downs on Derby Day.
Pen and ink.
Lent by Michael Heseltine.

105. I have lost my ticket number.
Pen and ink 7.8 x 15.1 cms.
The discomfiture of a gentleman confronted by hundreds of hats in a cloakroom.
Lent by Lionel Lambourne.

All the above works date from the same period as **Bird's Eye Views of Society,** 1864.

106. **Bird's Eye Views of Society** No IX A Popular Entertainment.

107. **Bird's Eye Views of Society** No XVI The Smoking Room at the Club.

108. **An Overland Journey to the Great Exhibition,** 1851.

109. Proof sheet for Oliphant's **Piccadilly,** 1870.
A tale of an ill fated romance in high society. Doyle's illustrations depict the temptations of society to those unaware of its evils.
The above four works lent by Michael Heseltine.

110. Lion Worship, Politicians Fishing, Worshipping the Rising Sun, Celebrities Performing.
Four sheets on one mount, each approx 5 x 30.2 cms.
Lent by the British Museum 1886-6-19-36 . . . 35 . . . 34 . . . 37.

111. Queen Victoria and Prince Albert reviewing the troops in Hyde Park in the company of the Duke of Wellington—from a sequence of nine ink drawings of the review.
Each 11.5 x 24.5 cms.
Lent by Michael Heseltine.

112

112. A copy of the Catalogue of the Art Treasures of the United Kingdom, collected at Manchester in 1857.
Size of volume 18.9 x 12 cms.
Victoria & Albert Museum.
Open at a sketch by Doyle of children looking apprehensively at some suits of armour labelled DO NOT TOUCH.

113. Letter to Tom Taylor.
Richard Doyle at ease in his club. Richard Doyle, like Edward Lear and Edward Burne-Jones, delighted in embellishing personal letters with amusing self-caricatures.
Lent by Alan Cuthbertson.

114. Letter to John Leech, circa 1855.
Concerning a visit to the Isle of Wight with a sketch of Doyle approaching the island in a steam paddle boat and Leech watching his arrival through a telescope.
Lent by Victoria and Albert Museum Library.

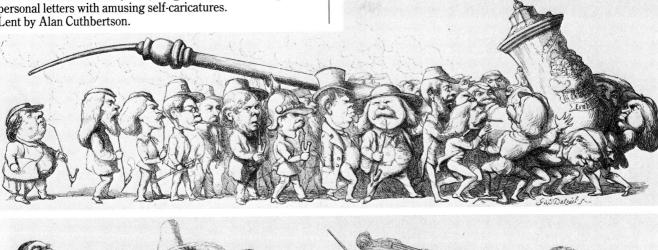

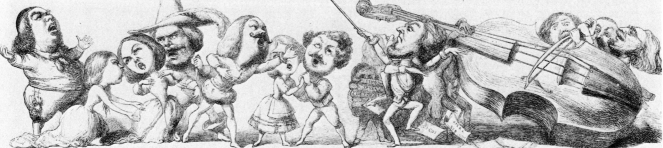

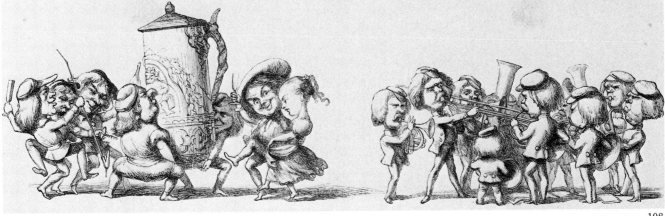

108

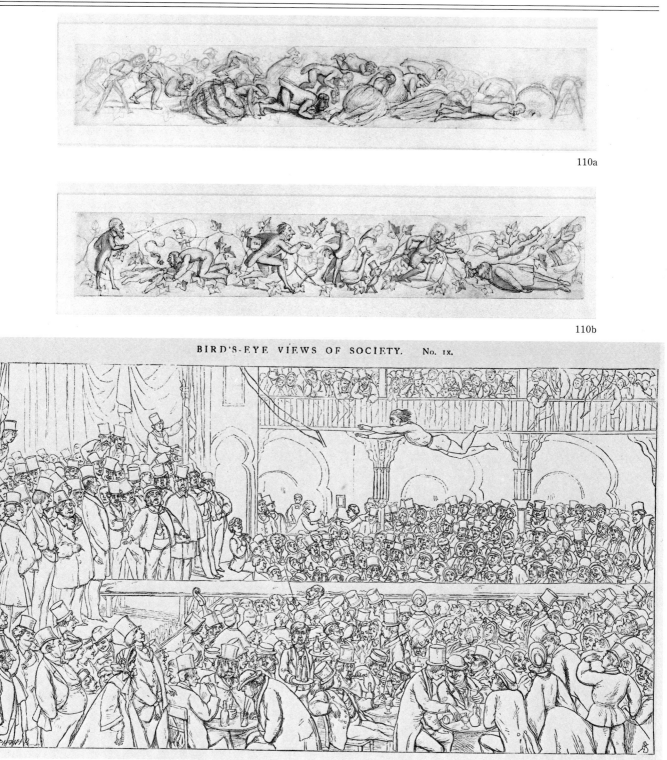

110a

110b

BIRD'S-EYE VIEWS OF SOCIETY. No. IX.

106

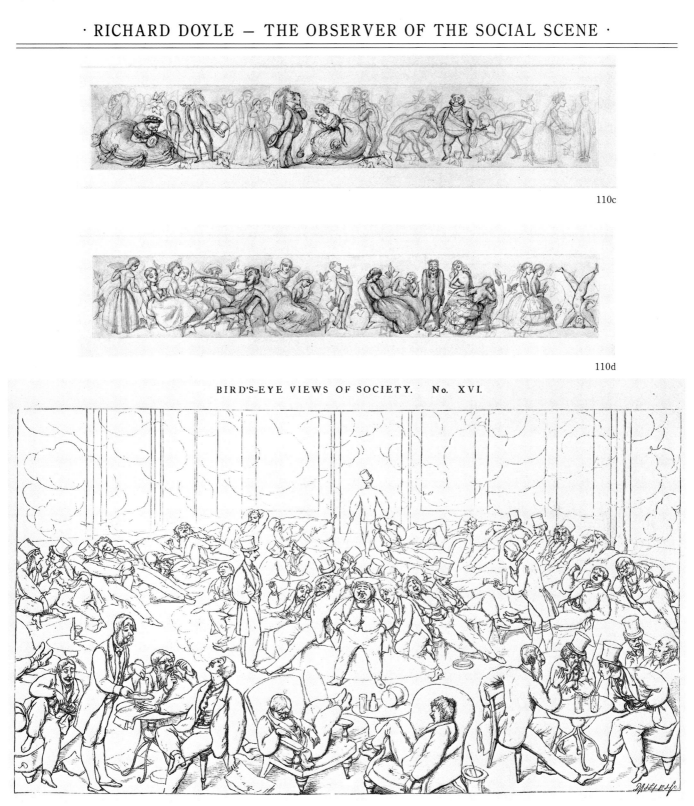

110c

110d

BIRD'S-EYE VIEWS OF SOCIETY. No. XVI.

107

WITH the rise of published editions of fairy-tales, most notably translations of the Brothers Grimm, a new market for illustrated fairy-tales emerged throughout the 1830s and 1840s. With it came the acknowledged master of the genre, George Cruikshank. Doyle's first attempt at illustrating fairy-tales, in *The Fairy Ring*, 1846, was heralded as a remarkable accomplishment which, in some critics' eyes, had replaced Cruikshank's supremacy. Doyle followed it up with the tremendously successful Montalba *Fairy Tales from all Nations*, 1849, which remained in print throughout the 1890s. His boyhood fascination with fairy stories had been put to good use in illustrations to anthologies of fairy stories, with his inimitable delicate borders of elves, pixies, fairy queens and mythical creatures and animals stretched around the edge of a page or squeezed into an initial letter. The best examples appeared in his *Juvenile Calendar and Zodiac of Flowers*, 1849. He branched out into contemporary fairy-tale books in *The Enchanted Doll*, 1849, as well as in Planché's retelling of the Sleeping Beauty tale in *An Old Fairy Tale Told Anew*, 1865. Later still he illustrated the tales of Knatchbull-Hugerssen in *Higgledy-Piggledy*, 1876, basing the drawings upon subjects he had begun to paint for the London galleries.

RE

FAIRY TALES AND THE SUPERNATURAL

115. The Knight and the Spectre.
Watercolour 19.5 x 35.5 cms.
Lent by the National Gallery of Ireland, Dublin.
Acquired by Henry Doyle at the 1886 Christie's sale for the National Gallery, Dublin. Another version is in the British Museum.

116. Battle of Elves and Crows.
Signed and dated 1874.
Watercolour 50.4 x 80.6 cms.
Lent by E.Joseph, Bookseller.
Exhibited with a similar work **Battle of Elves and Frogs** at the Grosvenor Gallery exhibition of 1885 lent by Lord Carlingford.

117. Beauty and the Beast.
Pen and ink over pencil 11 x 12.2 cms.
Lent by Lionel Lambourne

118. Titania and Bottom
Pen and ink
Lent by Brinsley Ford C.B.E., F.S.E.

119. J.L.C. and W.C.Grimm **The Fairy Ring**, 1846.

120. Mrs T.K.Hervey: '**Juvenile Calendar and Zodiac of Flowers**, 1849.

121. Anthony R.Whitehill—'Montalba' **Fairy Tales from all Nations** 1849.

122. J.R.Planche **An Old Fairy Tale Told Anew** 1866.

123. E.H.Knatchbull-Hugessen **Higgledy-Piggledy** 1876.
The above five books lent by Michael Heseltine.

117

ALTHOUGH Dicky Doyle was above all an illustrator who loved the imposed disciplines of the border, the initial letter, or a story with a straightforward narrative line, he was also, particularly in later life, an artist who took very seriously the more extended use of the watercolour medium on a large scale. Many of these large scale works rely compositionally on an imposed self discipline provided by the insertion either of the branches of a tree or its gnarled roots. Against these frameworks are arranged interlinked lines of the animated tiny figures of fairies. He achieved the effect of their minuteness by juxtaposing their activities against natural forms to achieve magical effects of diminuition of scale.

In these works we see Dicky Doyle's originality at its most striking, and they represent not only the high Victorian delight in the escapist world of faery at its most developed form, but also the need to fantasise the existence of extra terrestial beings which is such a recurrent feature in man's make-up, and finds its twentieth century expression in science fiction stories and films.

LL

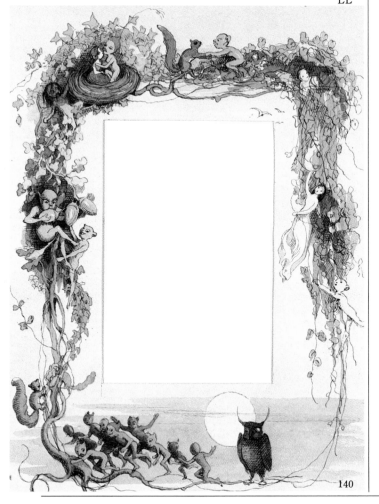

140

THE FAIRY WORLD OF DICKY DOYLE

124. The Fairy Tree, or a Fantasy based on 'The Tempest' by William Shakespeare.
Signed and dated 1845 lower right.
Watercolour 81.2 x 58.4 cms.
Collection of J.Page.
Exhibited as **The Enchanted Tree** at the Royal Academy, 1868 (727).
Brighton Art Gallery **Follies and Fantasies** 1971 (110).
Fine Art Society **Victorian Paintings** 1977 (57).
Richard Doyle only exhibited two paintings at the Royal Academy, of which this is one, the other being a work called **The Haunted Park.** Significantly, no specific lines from Shakespeare's play were quoted in the catalogue when the painting was exhibited at the Royal Academy, for it conveys the spirit of the play's supernatural happenings rather than illustrating any particular incident.

125. The Fairy Tree.
Watercolour 73 x 61.7 cms.
Lent by William E.Wiltshire III, Richmond, Virginia, U.S.A.
Literature: Jeremy Maas, **Victorian Paintings,** London, 1969, reproduced p. 156. Christopher Wood, **The Dictionary of Victorian Painters,** Suffolk 1978, reproduced p. 587.
One of Richard Doyle's largest and most famous watercolours, which portrays over 200 fairies on the bare branches of a tree, gazed on in wonder by a boy. On a central branch sits a Fairy King who is having his long moustaches combed by a number of female fairies. Hair had a peculiar fascination for Doyle, and he loved to draw luxuriant tresses being braided and plaited into sinuous and convoluted intricacies.

126. The Enchanted Tree.
Watercolour 35.6 x 60 cms.
Lent by David Rust.
Painted for Lord Aberdare. The beech tree grew on the side of an old lane in Studley Royal Park. Another version was painted for Lady Ripon representing a 'Bal Poudree' of the Fairies.

127. The Fairy Minuet.
Signed with monogram and dated 1871.
Watercolour 39 x 52.9 cms.
Private Collection.

128. Under the Dock Leaves:— An Autumnal Evening's Dream.
Signed and dated 1878.
Watercolour 26.7 x 77.1 cms.
Lent by the British Museum 1886-6-19-17.
The contrast provided by the dark green of the great dock leaves and the radiant colours of the fairies and startled kingfisher is particularly effective.

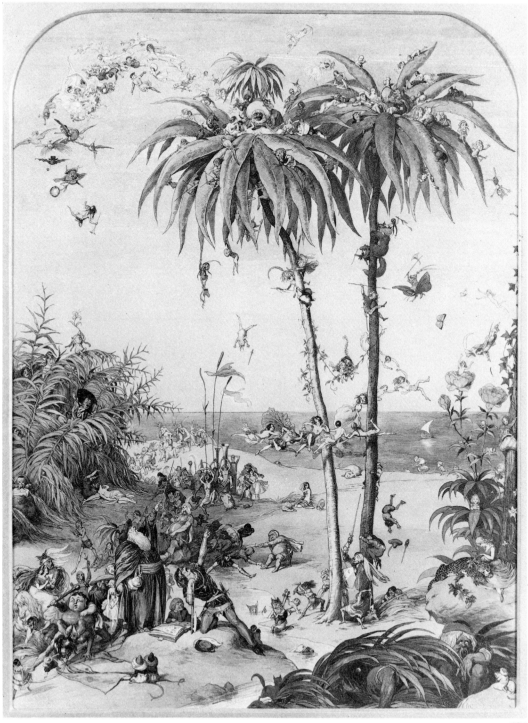

124

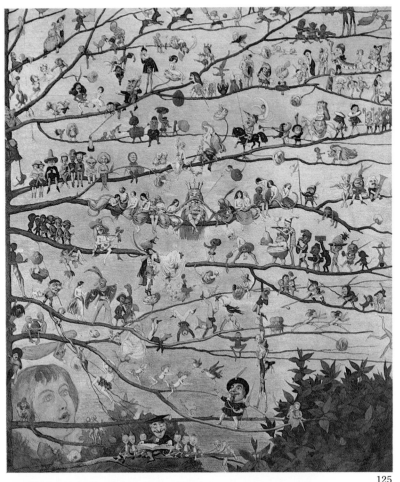

125

129. The Triumphal Entry, a fairy pageant.
Signed with monogram lower right.
Watercolour 50 x 84 cms.
Lent by the National Gallery of Ireland, Dublin.
This work, acquired by Henry Doyle in his capacity
as Director of the National Gallery of Ireland at the
Christie's Richard Doyle sale of 1886 is one of the
largest, latest and most important of Richard's
fairy works.

130. Elves in a Rabbit Warren.
Watercolour 50.4 x 80.6 cms.
Lent by E. Joseph, Bookseller.
The theme was re-used in Richard Doyle's
illustration to E.H.Knatchbull-Hugessen's
Higgledy-Piggledy, 1876.

131. Riding Through the Air.
Pen, ink and watercolour.
Lent by the Cecil Higgins Art Gallery, Bedford.

134. A Ladies fan with a design of fairies in
a nest on the front, and Aerial riding on a bat on
the back.
Watercolour. Each leaf 24.8 cms. Overall width
43.6 cms.
Lent by the Fine Art Society, London.
Given by Richard Doyle to Lady Annabel Cowper on
the occasion of her marriage to Lord Walter Kerr,
later Admiral of the Fleet, 18th November, 1873.

135. The Owl and the Fairies.
Watercolour 15.75 x 15.75 cms.
Lent by Alan Cuthbertson.

136. The May Queen c. 1870.
Pen and watercolour over pencil 21.4 x 29.3 cms.
Lent by Michael Heseltine.

137. Wood Elves hiding and watching a Lady.
Signed.
Watercolour 13 x 35 cms.
Bethnal Green Museum, Dixon Bequest.

138. The Good Fairy returning from the
Christening of the Sleeping Beauty.
Watercolour 37.2 x 50.7 cms.
Lent by William E. Wiltshire III, Richmond, Virginia,
USA.

139. A Fairy presenting a Rose to his Love.
Signed with monogram.
Lent by Richard Martineau.

140. Border with elves, squirrels and owl.
Watercolour 19.4 x 14.3 cms.
Lent by Michael Heseltine.

134 Front

IN Fairyland published by Longman, Green and Company in 1870, must be considered Richard Doyle's masterpiece, and it reveals his secret fairy world at its most enchanting. It was a particularly enjoyable commission, for he was given by the publishers a completely free hand, and produced some of his most imaginative pictures for he was free to develop his own ideas. William Allingham, the Pre-Raphaelite poet, was given the difficult task of fitting a verse framework to the plates. He was the obvious choice for the job, as his poem *The Fairies* — with its famous lines: —

> Up the airy mountains
> Down the rushing glen
> We daren't go a-hunting
> For fear of little men

is one of the most successful Victorian fairy poems. But none of his verse for *In Fairyland* reaches the same level, and the book owed its sensational success to the superb production standards set by its printer Edmund Evans, who adapted and surpassed the colour printing technique introduced by George Baxter to make it one of the masterpieces of Victorian book production. It is for that reason particularly rewarding to see in this exhibition Richard Doyle's own hand coloured proofs for the book, which Evans followed with such care, unlike the more cavalier approach adopted to art work by the famous firms of wood engravers Dalziel and Swain. Andrew Lang, some years later in 1884, significantly just after Richard Doyle's death, used mutilated details from the original blocks to illustrate his story *The Princess Nobody.*

LL

IN FAIRYLAND
OR PICTURES FROM THE ELF WORLD

The following items are four of the most important examples from the complete set of 36 watercoloured proof impressions in the outline key block for **In Fairyland.** These proofs were hand coloured by Richard Doyle to provide guidance for the technicians of the printing firm of Edmund Evans who prepared the colour separation blocks for the first edition of the book, published by Longman, Green, Reader and Dyer, London, 1870. The set of proofs were sold by Henry Sotheran & Co. to the Hon. Charles Ellis; . . .; obtained by Justin G.Schiller, Ltd (New York) from the Conan Doyle Estate and sold to the present owner in 1978.
Lent by a Private Collector, Switzerland.

141. Rehearsal in Fairy Land. Musical Elf teaching the young birds to sing. The artist's original hand coloured proof for plate I.

142. Triumphal march of the Elf King. This important personage, nearly related to the Goblin family, is conspicuous for the length of his hair, which on state occasions it requires four pages to support. Fairies in waiting strew flowers on his path, and in his train are many of the most distinguished Trolls, Kobolds, Nixies, Pixies, Wood-Sprites, birds, butterflies, and other inhabitants of the kingdom. The artist's original hand coloured proof for plate IV.

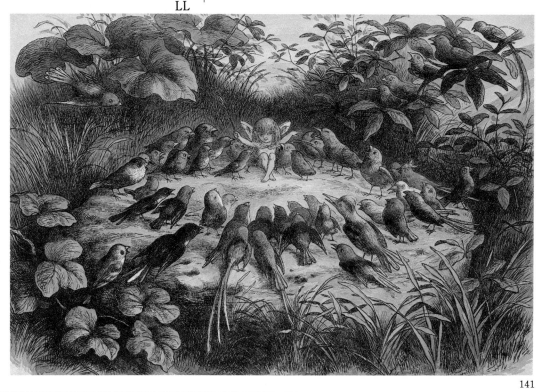

141

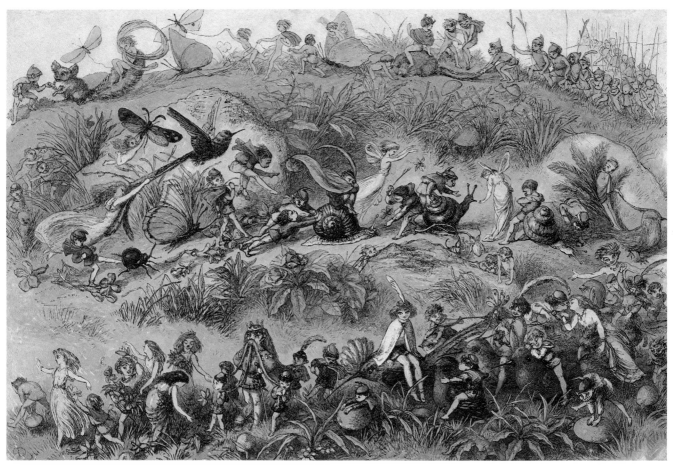

142

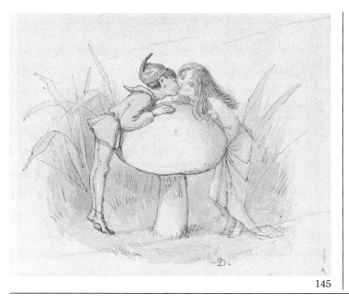

145

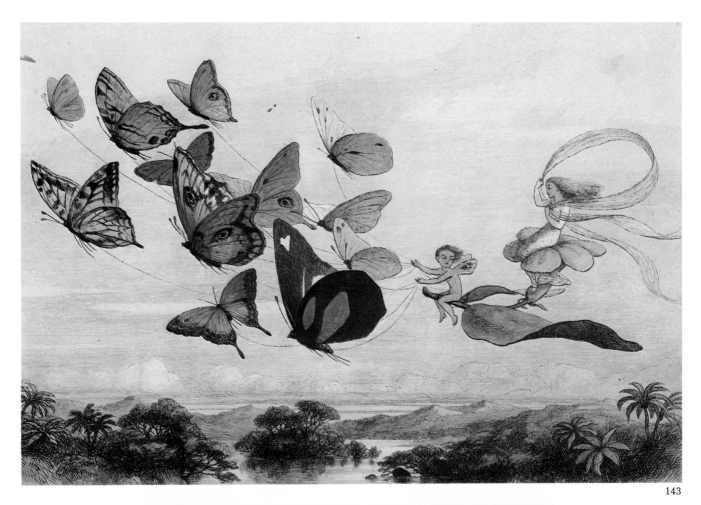

143

134 Back

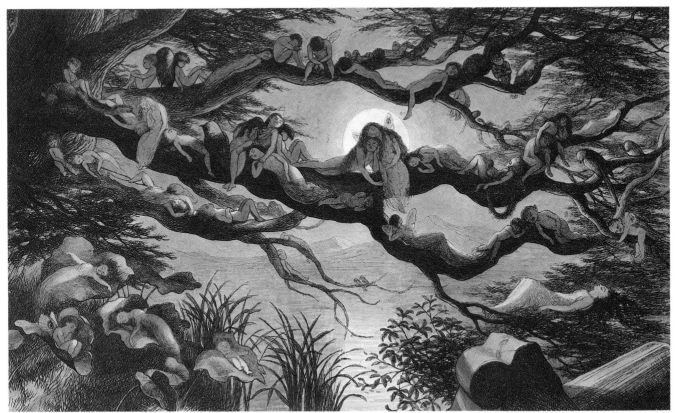

144

143. The Fairy Queen takes an airy drive in a light carriage, a twelve-in-hand, drawn by thoroughbred butterflies. The artist's original hand coloured proof for plate XIII.

144. Asleep in the moonlight. The dancing elves have all gone to rest; the King and Queen are evidently friends again, and, let us hope, lived happily ever afterwards. The artist's original hand coloured proof for plate XVI.

145. He finds her and this is the consequence.
Signed RD.
Watercolour 6 x 8 cms.
Victoria and Albert Museum E 387—1948.
Richard Doyle's original version of the second scene of 'a little play in three acts' — plate VIII.

146. Plate VIII from **In Fairyland** Ist edition, 1870.
Coloured wood engraving 27.5 x 39.9 cms.
Victoria and Albert Museum.
This is a little Play, in Three Acts. Scene: a Toadstool.
Characters: a sentimental Elf and a wayward Fairy.
Enter, an Elf in search of a Fairy. He finds her, and this is the consequence. She runs away, and this is his condition.
The quality of Edmund Evans coloured wood engravings, and the extreme precision of the wood blocks, can be seen here to have matched Doyle's watercolour with remarkable fidelity.

147. A sheet of sketches: studies for **In Fairyland.**
Pen and pencil 24.6 x 34.6 cms.
Lent by the British Museum.
Two of the subjects drawn on this sheet are preliminary designs for **The Fairy Prince's Courtship** Plate II, and **Dressing the baby Elves** Plate IX.

148. Three small sketches for **In Fairyland.**
Various sizes.
Pen, ink and wash.
Lent by Michael Heseltine.

149. The cover and spine of the binding of the Ist edition of **In Fairyland.**
Embossed cloth 40.8 x 29.9 cms.
Victoria and Albert Museum.
A fine example of Richard's ability to add magic even to the design of a commercial binding.

DICK Doyle was a keen collector of folk legends and stories, a habit he started from childhood, when he relished accounts told by Walter Scott of the supernatural. As an illustrator of fairy-tales, he discovered foreign folk legends and became especially taken by those involving strange creatures. He was regarded as the supreme master of dragon illustrations by his critics during his lifetime, and adopted a whimsical as well as the more traditional ferocious approach, and painted versions of the Dragon of Wantley as well as the St George and the dragon theme. Witches and trolls fascinated him and he painted numerous versions of withered old crones and nature spirits, borrowing legends from Wales, Denmark and Norway, as well as West Country legends of giants and pixies, strange apparitions seen across a Scottish loch, and the more endearing legend of Dame Julianna Berners, authoress of the first fishing treatise.

RE

FOLK TALES AND LEGENDS

150. The Dragon of Wantley.
Watercolour 24.8 x 44.9 cms.
Lent by the British Museum.
Another version is in the National Gallery, Dublin. The Dragon of Wantley lived in Lancashire, and was the terror of all the countryside. He had 44 iron teeth, and a long sting in his tail, breathed fire, and once ate three young children. He was finally killed by Sir More of More Hall, who had a suit of armour made in Sheffield, set all over with iron spikes, each five or six inches in length.

151. The Altar Cup of Aagerup.
Signed and dated 1883.
Lent by the Cecil Higgins Art Gallery, Bedford.
One of the last works completed by Richard, a reiteration of a theme he had painted before taken from Thomas Keightley's **The Fairy Mythology,** 1828. The old Danish story tells of a farmer's servant in the village of Aagerup in Zealand who spends Christmas Eve with the trolls. As day breaks he mounts his horse to ride home, and is invited to drink a stirrup-cup. Suspicious, he throws the drink over his shoulder, and it immediately singes the hair on the horse's rump. He gallops away, the trolls in pursuit, vowing to give the cup, still in his hand, to the church as an altar cup, if he escapes.

152. A Welsh Legend — 'One peculiarity of the Cambrian fairies is that, every Friday, they comb the goat's beards to make them decent for Sunday'.
Watercolour 50.4 x 80.6 cms.
Lent by Witkin Gallery, New York.
Other versions are known of this attractive subject.

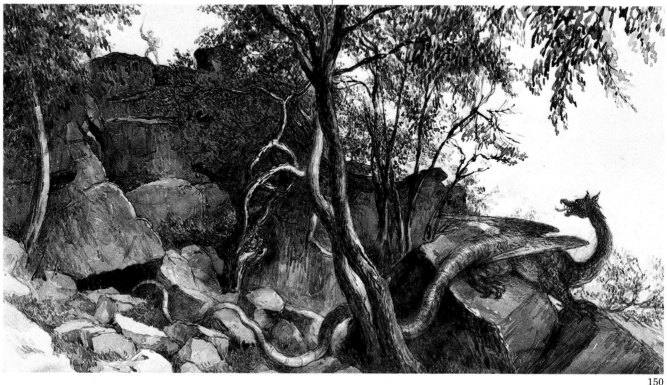

150

151

153. Dame Julianna Berners Teaching her young Pupils the Art of Fishing.
Watercolour 25.2 x 75.6 cms.
Lent by E. Joseph, Antiquarian Bookseller.
This picture, one of the last works exhibited by Richard Doyle at the Grosvenor Gallery in 1883, depicts the celebrated beauty and prioress of the nunnery of Sopwell, Hertfordshire, who wrote the first treatise on fishing, published at St Albans in 1486. Both Richard and Charles were keen anglers, Richard producing his own unpublished illustrated version of the Dame's treatise.

154. Rose Red.
Watercolour 20.2 x 28.9 cms.
Lent by Mrs Mathew.

155

157

155. Snow White.
Watercolour 10 x 13.6 cms.
Lent by Michael Heseltine.
These two watercolours are illustrations for an unpublished version of Rose Red and Snow White.

156. The Knight and the Jötun.
Watercolour 11.2 x 17.8 cms.
Victoria and Albert Museum. E 388 — 1948.
A Norse legend. A Jötun is a Scandinavian giant.

157. On the Way to War.
Watercolour 34.6 x 49.7 cms.
Lent by the British Museum. 1886-6-19-4.

158. The Manners and Customs of Monkeys (Darfur, Africa).
Signed and dated 1877.
Watercolour 9½ x 17²/₃ ins.
Victoria and Albert Museum 336 — 1880.
Exhibited Grosvenor Gallery 1881 (281).

At the Grosvenor Gallery exhibition the catalogue entry quoted the following typically Victorian racist story from **The Pall Mall Gazette** which presumably inspired Doyle:

'According to a recent letter from Darfur, in Africa, the monkeys in that region are inordinately fond of a kind of beer made by the natives, who use the beverage to capture their simian poor relations. Having placed a quantity of the beer where the monkeys can get it, the natives wait till their victims are in various degrees of inebriation, and when they then mingle with them, the poor creatures are too much fuddled to recognize the difference between negro and ape. A negro then takes the hand of one, the others follow, holding on to one another, and they are led off into captivity'.

159. A series of six watercolours telling the story of Jolly Jack Ashore, with a box of red nightcaps and his adventures with some monkeys.
All signed with monogram.
Watercolours. Each 17 x 24 cms.
Lent by Victor Hutchins.

The first Five of the original captions in Doyle's hand have survived, and tell the following story:

No. 1. A Sailor, once upon a time, left his Ship on the coast of Africa, taking with him a box of Red nightcaps which he hoped to sell at the nearest town. He is represented here about to lie down and rest on his journey, having first taken one of the Red caps and placed it on his head and not thinking that he was watched by the monkeys seated up in the trees.

No. 2. Shows the Monkeys in the act of stealing quietly down from their branches and stealthily approaching the sleeping 'Jack Ashore'.

The 3rd Chapter tells how the Monkeys, having opened the Box, stolen the Caps, and fitted themselves hastily, are scampering off to a place of safety.

In No. 4 we see how they, having regained the tree-tops, are much pleased with themselves, and chatter with delight at their own cleverness. The Sailor meantime refreshed with his nap, woke up, and flung his cap on the ground.

The next incident (No. 5), shows how the Monkeys having, with observing eyes, beheld the cap thrown down, all took the caps from their heads, and dashed them down, just as Jolly Tar discovered his loss and was shouting nautical oaths with rage.

Unfortunately, Doyle's last caption is lost, but we see the sailor having repacked his box trudging off, and peace returning to the jungle.

160. John Ruskin, **The King of the Golden River** 1851.

163

161. The Story of Jack and the Giants 1851.
Wood engraved proofs.

162. Jack the Giant Killer 1842, published 1888.

163. The Eagle's Bride — She hid behind a Rose Bush.
Watercolour 13.7 x 17.7 cms.
Sketches for this watercolour are in the nonsense sketchbook catalogue no 39.

164. The Eagle's Bride — The White Knight to the Rescue.
Watercolour 20.1 x 14.3 cms.

The above four items lent by Michael Heseltine.

165. Thomas Hughes, **The Scouring of the White Horse,** 1859. This copy was specially bound by Nutt of Cambridge for the author Thomas Hughes, and presented by him to his godson, Richard Ford (the father of the present owner), at his baptism in March, 1860. The design by Dicky Doyle on the binding is not taken from an illustration in the book. Thomas Hughes monogram appears on the front of the book, that of Richard Ford, surrounded by the same design, on the back.
Lent by Brinsley Ford, C.B.E., F.S.A.

166. Another copy of **The Scouring of the White Horse,** 1859.
Lent by Michael Heseltine.

158

AFTER his *Punch* resignation, Doyle spent a great deal of time away from London. He had built up a large and impressive collection of influential political and aristocratic acquaintances, and was a much sought-after addition to many a country house party, often spending weeks away from London on a circuit of the grander houses. This severely damaged his artistic career, especially towards the end of his life when he seemed to bury himself in society and shun work unless he needed the money. Then he turned to landscape watercolours, often of his wealthy friends' estates or houses, which he painted for the Grosvenor Gallery. He painted and explored some of the country's grandest houses and estates, from Longleat, Castle Howard, Chatsworth, Wilton House to the grounds of Raby Castle, and Egerton Castle. He especially liked Scotland for its bleak landscape, and spent some time on the west coast, exploring the landscape of Skye, Canna Island, and the lochside shores near Invergarry. He felt only the Scottish landscape had the correct ethereal quality he wanted as backgrounds for his fairy and supernatural pictures, and in the end, despite numerous landscape paintings in tight, stipple, almost impressionistic style, which he completed for the Grosvenor Gallery, only the fairy paintings proved successful with critics and more importantly his patrons.

RE

LANDSCAPES AND COUNTRY HOUSES

167. Canon J.E.Jackson and Frances, 4th Marchioness of Bath, in the Library at Longleat, 1874.
Watercolour 34.4 x 49.8 cms.
Literature: David Burnett; 'Longleat — the Story of an English Country House', Collins, 1978.
Lady Frances Vesey, born in 1835, married the 4th Marquess of Bath. She died in 1915. She is seen in conversation with Canon Jackson (1805-1891) F.S.A., Rector of Leigh Delamere near Devizes, who was an antiquary and topographer, and an authority on John Aubrey and Wiltshire. From 1863 until his death he catalogued the library at Longleat.

168. Lady Beatrice Thynne (1867-1941).
Pencil 16.4 x 18.1 cms.
One of eleven charming drawings of the six children of the 4th Marquess and Marchioness of Bath, who were drawn by Richard Doyle during visits to Longleat in the early 1870s. He had become a friend of the 4th Marquess in the early 1850s and seems to have made several visits to Longleat, painting four views of the grounds and library.
Both the above works lent by the Marquess of Bath, Longleat House, Warminster, Wiltshire.

169. Isel Hall, Cumberland.
Signed with monogram and dated 1879.
Watercolour 47.7 x 78.4 cms.
Lent by the National Gallery of Ireland, Dublin.
One of Richard's largest and most impressive landscape watercolours.

170. Loch Quoich, Invernesshire
Inscribed: Loch Quoich, from drawing from window.
Watercolour on two sheets each 11.3 x 24.3 cms.
Lent by the British Museum.
A continuous panoramic view of the waters of the loch enclosed on all sides by purple hills. In the right foreground is a garden bordering on the loch with herons on the beach. A work which reveals Richard's real powers in the more conventional discipline of the watercolour medium — landscape.

171. The Witch's Home, No 1. 'Broom waiting: coming out.'
Signed and dated 1875.
Watercolour 35.3 x 50.6 cms.
Victoria and Albert Museum 334 — 1880.

171

170

172. The Witch's Home, No 2. 'She's Off!'
Signed and dated 1875.
Watercolour 34.8 x 50.9 cms.
Victoria and Albert Museum 335 — 1880.
Both these works were painted on, and depict
the landscape of, the Isle of Canna, near Skye,
now owned by the National Trust. Richard
visited the island on the yacht of a friend,
Robert Lowe (later Viscount Sherbrooke).
One will be reproduced in a forthcoming book
on the island by John L. Campbell, to be
published by the Oxford University Press.

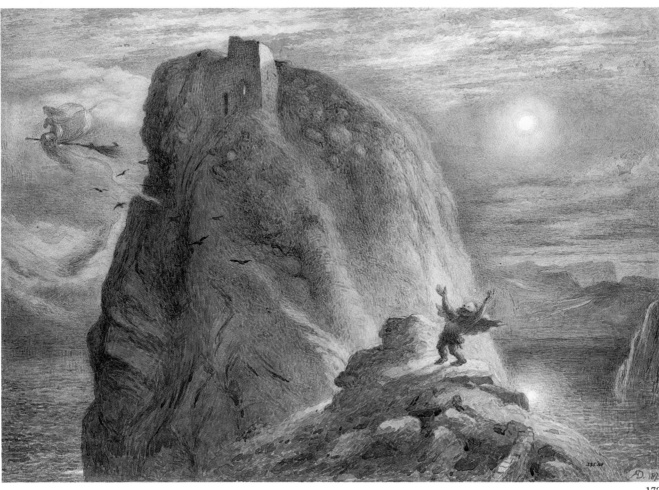

172

Soon after Charles's birth in 1832 his mother Marianna (Mary) Doyle died. The happy family circle depicted with such affection in the pages of Richard's *Journal of 1840* had therefore no mother at its centre as controlling influence, a fact which would inevitably have affected the upbringing of the youngest child. Lacking maternal affection in his formative years, and encouraged but outshone by his more secure and brilliant elder brothers and sisters, it is not surprising that he seems to have grown up with an errant character both engaging and demanding.

It was perhaps for this reason that his father John, who one may fairly deduce played a decisive rôle when his children's careers were under discussion, encouraged Charles in 1849 at the relatively early age of seventeen to leave home for Edinburgh, thinking that it would benefit his youngest son to make his own way in life. Charles had been trained as an artist, but John may have dissuaded him from following that profession. After all,

one son, Richard, had already elected to follow in his own footsteps as a caricaturist, a career which Charles, with his more diffident nature, would have found taxing, and the opening of assistant to the Surveyor in the Scottish Office of Works, must have seemed the gateway to a secure future.

Plunged in Edinburgh into a demanding new job which required the skills of architect and builder as well as draughtsman, Charles, one suspects, felt desperately lonely and starved of the affectionate home background which he remembered with nostalgia fifty years later (see his description on p8), but within six months he met and fell in love with the girl whom he was to marry five years later.

Mary Foley (1838-1921) known revealingly as 'The Ma'am' by her family of ten children of whom two sons and five daughters survived, was a woman of firm and determined character, a

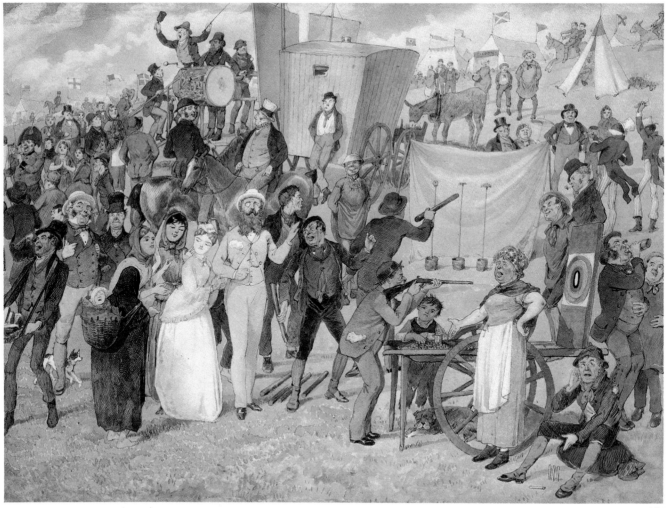

181

doctor's daughter extremely well read, with a passionate pride in her family descent on her mother's side back to the Plantagenets. In Charles she seems to have found that strange affinity which often attracts strong minded women to ineffectual but charming men. For Charles was paradoxically, both the weakest and the strongest link in the Doyle family.

He was to hold down his job for nearly thirty years, never earning more than £250 a year, supplemented by about £60 from his earnings as book illustrator and painter, although he gave away as many pictures as he sold. His son Arthur recalled him at as 'a tall man, long-bearded, and elegant; he had a charm of manner and courtesy of bearing which I have seldom seen equalled. His wit was quick and playful. He possessed, also, a delicacy of mind which would give him moral courage enough to rise and leave any company which talked in a manner which was coarse . . . he was unworldly and impractical and his family suffered for it.'

There is something of Wilkins Micawber about Charles in these Edinburgh years, always waiting 'for something to turn up', for the call from London to fame as an artist that never came. With middle age these frustrated hopes led to the anodyne of alcohol, which combined with the onset of epilepsy resulted eventually in his incarceration in Montrose Royal Lunatic Asylum — the ironically named 'Sunnyside' of the sketchbooks. But although their marriage thus ended in tragic separation, doubtless because of Mary's firm refusal to cope both with the immense strain of living with a chronically ill husband while bringing up virtually single-handed a large family of children, it is significant that all Charles's references to her in his journal are affectionate ones, except for reproaches for the lack of her acknowledgement of his work.

LL

CHARLES ALTAMONT DOYLE 1832-1893

173. Arthur's Seat.
Watercolour 17 x 23.9 cms.
Lent by Lady Bromet, D.B.E.
King Arthur's Seat, the hill which dominates the Edinburgh skyline is here transformed by Charles into the gigantic figure of the ancient King. Edinburgh was his home from the age of 17 in 1849, although this drawing, a page from a dismembered Sunnyside sketchbook, dates from his later unhappy years in the 1880's.
173a. The Irish Packet.
Watercolour—Lent by Alan Cuthbertson.
174. Menu card design, showing a chamber maid flirting with a waiter.
Signed in pencil C.A.Doyle.
Watercolour 22.6 x 18.7 cms.
Commissioned by George Waterson and Son, Edinburgh.
An early work showing Charles's direct illustrative powers before the onset of his illness.
Lent by Mr John Robertson.

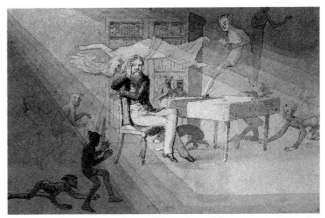

Books illustrated by Charles Altamont Doyle
175. Coelebs the Younger in Search of a Wife (1859).
Lent by Michael Heseltine.

176. The Long Holidays (1861).
The Victoria and Albert Museum.

186

177. The Book of Humourous Poetry (1867).

178. Our Trip to Blunderland (1877).
Both the above lent by Michael Heseltine.

179. Lady's fan. On the front figures of a Harlequin, Geisha, Scotsman, Red Indian, Milkmaid, Chinaman, Knight in armour etc. On the back a design of flowers.
Watercolour on silk. Each leaf 16 cms. Overall width 54 cms.
Like Richard, Charles also enjoyed the challenge presented by working on the unusual shape of a fan, as these animated dancing figures show.
Lent by Mr John Robertson.

180. Victorian Mermaids on the Shore.
Watercolour 22 x 34.6 cms.
Private Collection.
An amusing example of Charles' droll humour in a large watercolour of the type he exhibited in his early untroubled years.

181. Bank Holiday.
Watercolour 27.3 x 37.1 cms.
Lent by the National Gallery of Ireland, Dublin.
Exhibited **Bank Holiday** Fine Art Society 1982.
A vivacious example of Charles' power as an observer of the social scene. It contains, in the bearded man to the right of the centre of the sheet, a self portrait. This jolly figure forms an interesting comparison with the gloomy self portrait in **Meditation.**
(No 186).

182. The Eagle's Bride.
Watercolour 34 x 23.3 cms.
Lent by Lady Bromet, D.B.E.
A theme often used by Richard Doyle is here given a characteristically slightly sinister interpretation by Charles.

183. Fairies a Wooing.
Watercolour 25.8 x 20.1 cms.
Lent by Michael Baker.
Previously exhibited **Victorian Fairy Paintings** Jeremy Maas Gallery, 1978; **Fairies** Brighton Museum and Art Gallery, 1980.

184. A Fairy Lecture.
Watercolour 17.6 x 24.9 cms.
Lent by
Elves, dogs and a frog seated round a toadstool, which is used as a lectern by the fairy lecturer. On the back is a self portrait of Charles being beaten by two housemaids inscribed 'What the rugs get at Sunnyside. You may hear the awful row about 7 a.m.'

185. Hyacinth's start in early life. Here she comes!
Watercolour 17.5 x 25 cms.
Lent by Brigadier J.R.I.Doyle, O.B.E.
A fine example of Charles's gift for combining botanical observation with his unique vein of fantasy. Inscribed 'To my mind this more suggestive than if more finished. Suggestive (under two fairies kissing, hiding behind a leaf) and 'Lawks!' exclaimed by another fairy.

186. Meditation.
Watercolour.
Victoria and Albert Museum.
A characteristic example of the introspective self portraits which fill the pages of the sketchbooks produced at Sunnyside. On the back is a drawing of a sycamore leaf.
Exhibited at the Charles Doyle exhibition organised by Sir Arthur Conan Doyle in 1924.

187. Sketchbook: Charles Altamont Doyle. His Buke 8 March 1889.
Lent by E.Joseph, Antiquarian Books.
This sketchbook achieved widespread attention when it was reproduced in facsimile in **The Doyle Diary, The Last Great Conan Doyle Mystery** by Michael Baker in 1978. It is open at the frontispiece annotated in pencil thus: 'keep steadily in view that this book is ascribed wholly to the produce of a MADMAN/ Whereabouts would you say was the deficiency of intellect? or depraved taste/If in the whole book you can find a single Evidence of either, mark/it and record it against me.
I am anxious for this . . . line erased . . . the other Book and any Notes that/have ever been made (word indecipherable). There are more than 167 distinct ideas in this Book/The object of all my jokes is to leave just a flavour of the solemn and have the effect of Bitter — As far as I know both Books are quite original — and where/too big might be photographed down to bookable size to fit text.
I am also very certain that my several New packs of Cards would be a prodigious Commercial/success if spiritedly carried out — but what has become of them all is concealed from me. 22nd May 1889.
I am not — well I will put off writing what I was going to say — till tomorrow/what I wanted to say was that I have now done a great many Vols. of ideas — but I am kept ignorant of/what becomes of them. I asked them to be all sent to Mrs. Doyle and

submitted to Publishers, but/as I have never had a single Book or Drawing acknowledged by her or other relatives I/can only conclude that they see no profit in them/In the circumstances I think it would be better that these Books should be entrusted to the Lunacy Commissioners/to show them the sort of Intellect they think it right to Imprison as Mad &/let them judge if there is any question for publication.
On the opposite page is a watercolour of a fairy standing by a white rose with a tortoise, inscribed 'WHICH IS THE PRIMEST OF THE ROSES?' and 'Who Ever saw a Tortoise with a Loving look before?'
Note: In Brigadier Doyle's collection is a design by Charles of playing cards inscribed 'The Miss Aces of Hearts and Spades being taken home by Little Clubs' which may relate to the packs of cards described above.

188. Sketchbook, drawn at Sunnyside.
Each page measures 27.4 x 17.6 cms.
Lent by E.Joseph, Antiquarian Bookseller.
Open at a double-page showing on the left a Scots piper playing for fairies who dance round corn stooks, signed and dated CAD 4th Oct 1888.
On the right a harvest scene, signed and dated CAD 8th Oct 1888.

189. Here's to Over the Hills and Far away.
Watercolour 16.5 x 10.4 cms.
Lent by Brigadier J.R.I.Doyle, O.B.E.
The resemblance of this sketch to the Scots piper in the sketchbook (188) is striking.

190. Here's to Jack Up Aloft.
Watercolour 17.7 x 11.2 cms.
Lent by Brigadier J.R.I.Doyle, O.B.E.
These two watercolours could possibly be designs for playing cards referred to in Charles preface to his 'Buke' (187). They have some resemblance to figures in a 'Happy Families' pack.

191. Celtic Cross.
Watercolour 34.5 x 25.5 cms.
Lent by Brigadier J.R.I.Doyle, O.B.E.
This watercolour possibly represents the other side of the memorial cross on page 21 in Sketchbook (187) which is inscribed 'When Ireland regains her Parliament, I hope and believe Her first Act would be to erect a Monument to the Memory of Lord Edward Fitzgerald, Brother of the Duke of Leinster, who was cruelly Murdered by Major Sirs(?), of the Police in 1798, — while gallantly struggling for the People's Emancipation. — The above is suggested as an appropriate design — A Runic cross with the Inscription indicated . . .'.

1859 Arthur Conan Doyle born 22 May in Edinburgh, the second child of Charles Altamont Doyle and Mary Foley.

1868 Attends Hodder, a preparatory school for Stonyhurst, where he stays two years.

1870 Enters Stonyhurst, a Catholic public school in Lancashire run by the Jesuit order, excelling at sport and showing early evidence of literary talent.

1874 Visits London, and is taken round all the sights by his uncle Richard with whom he stays. Enjoys Irving in *Hamlet,* and is very taken with the 'room of horrors, and the images of the Murderers' at Madame Tussauds.

1875 Spends a year at a Jesuit school at Feldkirch in Austria.

1876 Enrolls at Edinburgh University to study medicine, meeting Dr Joseph Bell, on whom Sherlock Holmes is based, and the anatomist Professor Rutherford, a model for Professor Challenger.

1876 Charles leaves the Scottish Office of Works in June, aged 44, on a pension of £150 a year.

1879 Charles enters a nursing home. Anonymous publication of the first Conan Doyle stories.

1880 Arthur signs on as ship's doctor with Arctic whaler. Shows first interest in psychical research.

1881 Graduates as M.D. Makes second voyage as ship's doctor to West Africa.

1882 Announces to the family in London that he has lost his Catholic faith. James particularly horrified. Arthur is left to set up as a doctor, at first briefly in Plymouth, and then at Southsea, a suburb of Portsmouth, where he practised for eight years, while establishing himself as a writer, and attending seances, to further his work.

1883 Richard Doyle dies.

1885 Charles enters Sunnyside. Arthur marries his first wife Louise Hawkins, the sister of a patient.

1887 The first Sherlock Holmes story *A Study in Scarlet* is published in *Beeton's Christmas Annual.* A year later, a second edition, illustrated by Charles, is published by Ward, Lock and Company.

1889 Daughter Mary Louise born. *Micah Clarke* published, and second Holmes mystery, *The Sign of Four.*

1890 Visits Berlin to investigate cure for tuberculosis. *The White Company* published.

1891 Leaves Southsea for Vienna to study the treatment of the eye. Returns to London and opens practice in Devonshire Place, but abandons medicine to write full time. Six Sherlock Holmes stories appear in *The Strand Magazine.*

1892 James and Henry die. The Conan Doyles visit Norway with Jerome K.Jerome where Arthur learns to ski. Shortly afterwards he helps introduce the sport to Switzerland. Son Kingsley born.

1893 Charles dies. Louise falls ill with tuberculosis, and is given a short time to live. In *The Final Problem* in *The Strand* Sherlock Holmes 'dies'.
Arthur joins the Society for Psychical Research.

1894 Lecture tour of America.

1895 Builds house in Hindhead, thinking that the Surrey air will help Louise. Takes her to Egypt for the winter. *The Stark Munro Letters* published.

1896 Travels up the Nile to the Sudan. Fighting breaks out with the Dervishes, and Arthur acts as war correspondent. *The Exploits of Brigadier Gerard* and *Rodney Stone* published.

1897 Meets and forms a deep Platonic relationship with Jean Leckie, later to become his wife.

1900 Joins hospital unit as Doctor and serves with the British army in South Africa. Returns to England and writes two books on the Boer War which state the British point of view in the conflict and are well received in pro-Boer Europe. Their success leads to him being offered, and accepting a Knighthood. Narrowly defeated as Unionist candidate at Edinburgh.

1902 Knighted. Sherlock Holmes returns in *The Hound of the Baskervilles,* a story dated before his 'death'.

1903 A tempting American offer leads to the revival of Sherlock Holmes in *The Strand. The Adventures of Gerard* published.

1905 *Return of Sherlock Holmes* published.

1906 Defeated as Unionist candidate at Hawick in general election. Becomes involved in Divorce Law Reform movement. Takes up cause of George Edalji, unjustly imprisoned in 1903. His first wife Louise dies. *Sir Nigel* published.

1907 Marries Jean Leckie. George Edalji released.

1909 Horrified by Roger Casement's revelations of atrocities in the Belgian Congo, Conan Doyle writes *The Crimes of the Congo.* Son Denis born.

1910 Takes up another case of unjust imprisionment, that of Oscar Slater, sentenced to life for murder in 1909. Conan Doyle continued to campaign for his release for seventeen years, and his success in righting the miscarriage of justice in both the Edalji and Slater cases was to lead to the establishment of the Courts of Appeal. Another son Adrian born.

1912 Professor Challenger appears in *The Lost World.* Daughter Jean born. *The Poison Belt* published.

1914 Publishes recruiting pamphlet *To Arms!*

1915 *The Valley of Fear* published.

1916 Visits British, French and Italian fronts. Unsuccessfully organises appeal for the reprieve of Sir Roger Casement, sentenced to death for treason. Converted to spiritualism through his contact via a medium with Malcolm Leckie, killed in action at the Battle of Mons.

1917 *His Last Bow* published. Elsie Wright (aged 15) and Frances Griffiths (aged 9) take photographs of 'fairies' at Cottingley in Yorkshire, which are to achieve notoriety three years later.

1918 Sir Arthur's son, Kingsley, dies of pneumonia after being wounded at the Somme. First book on spiritualism *The New Revelation*.

1919 Sir Arthur's brother Brigadier General Innes Doyle dies of pneumonia in France

1920 The Cottingley 'fairy' photographs are shown to Sir Arthur, who is researching for an article on the subject, just before his departure to Australia with his family on a Spiritualist lecture tour. He asks for rigorous tests to be made by Kodak and another photographic company. The results are contradictory, but Conan Doyle accepts the report of H.Snelling (subsequently revealed to have 'improved' the photographs) that 'These two negatives are entirely genuine'. Sir Arthur writes up the incident, which is published in an article in the December, 1920, issue of *The Strand* while he is in Australia. The article, entitled *Fairies Photographed,* causes a furore of press speculation which has continued until the present day.

1921 His mother, Mary Doyle dies. His wife Jean discovers her mediumistic powers.

1922 Lecture tour of America. *The Coming of the Fairies* published. Experiments in communicating, via mediums, with deceased members of the Doyle family.

1923 American and Canadian spiritualist lecture tours.

1924 Organises commemorative exhibition of the work of his father Charles Altamont Doyle in London, favourably reviewed by George Bernard Shaw.

1925 Presides over International Spiritualist Congress in Paris.

1926 Publishes two volume *History of Spiritualism, The Land of Mist*.

1927 Oscar Slater freed. The last Sherlock Holmes stories *The Case Book of Sherlock Holmes* published.

1928 South African, Kenya and Rhodesia tours.

1929 Scandinavia and Holland tours. On return, suffers a severe heart attack, but insists on speaking at Armistice day meetings.

1930 Just before he dies on July 7 draws *The Old Horse*, a revealing autobiographical allegory. Publishes *The Edge of the Unknown, The Marricot Deep*.

1983 After sixty five years of continuing speculation in the media, Geoffrey Crawley in ten articles in the British Journal of Photography conclusively establishes, the fraudulent nature of the Cottingley photographs, and the circumstances that led to the incident. Elsie Wright, the older girl, now aged 82, publishes during the series a revealing letter about her part in the affair, but Frances Griffiths, the younger partner, maintains that she did see fairies and that one of the five photographs was genuine.

HAY 68, Princes St EDINBORO.

192

SIR ARTHUR CONAN DOYLE, AND THE FAMILY LEGACY, THE FAIRY STORY

During his long career as a writer Sir Arthur Conan Doyle tried his hand successfully at virtually every literary form. Recruiting pamphlets, six volume histories of the First World War, autobiography, verse, novels, flowed from his pen with equal facility, and he was one of the greatest practioners of the short story. But although his work was avidly read by children, he surprisingly did not intentionally direct any works specifically at them, and never essayed the subject which his family had made visually so much their own — the fairy story.

Yet while eschewing the fairy story he frequently used the supernatural with good effect in many of his stories, although often demonstrating it to have a natural explanation, as in *The Hound of the Baskervilles*. He himself shared the widespread late Victorian interest in the paranormal from the age of twenty-one, and during his years in practice as a Doctor at Southsea he attended seances. In 1893 he joined the Society for Psychical Research, taking part in an investigation of poltergeist activity in an allegedly haunted house at Charmouth in Dorset. But his ceaseless literary activities prevented him from devoting much time to these investigations, and it was not until the coming of the 1914-1918 World War that his interests in spiritualism were to deepen. His own words, in his book *The New Revelation*, 1916, take up the story:– "I might have drifted on for my whole life as a psychical researcher, showing a sympathetic, but more or less dilettante attitude towards the whole subject . . . But the War came . . . In the presence of an agonised world, hearing every day of the deaths of the flower of our race in the first promise of their unfulfilled youth, seeing around one the wives and mothers who had no clear conception whither their loved one had gone to, I seemed suddenly to see that this subject with which I had so long dallied was not merely a force outside the rules of science, but that it was really something tremendous, a breaking down of the worlds between two worlds, a direct undeniable message from beyond . . . The objective side of it ceased to interest, for having made up one's mind that it was true there was an end of the matter".

Once convinced of the justice of a cause Sir Arthur was unstoppable and his conversion to Spiritualism was to be further re-inforced by the loss of six members of his family as a result of the war, including his son and brother. In his desire to communicate with the dead Conan Doyle expresses the anguish of a generation of humanity suddenly cut off from husbands, sons, brothers, lovers and fathers by the holocaust of the great war. During the last decade of his life he was to embark on an intense campaign to further the cause of Spiritualism, giving a series of five hundred lectures throughout the world, spending a quarter of a million pounds and writing books and articles. In this activity he was fully supported by his wife Jean.

Another concern which greatly preoccupied him in the early 1920's was an awakened interest in the work of his father Charles, which culminated in the organisation of a retrospective exhibition of his paintings in London in 1924, significantly subtitled "The Humourous and the Terrible", which was favourably reviewed by George Bernard Shaw. Although he had never been on close terms with his father and his mother, 'the Ma'am' had given him his love of history and the art of story telling. Arthur had kept in touch with Charles during the years at Sunnyside, as Charles's commission to illustrate *A Study in Scarlet* in 1888 demonstrates. With his own middle age and increased interest in the coming of death which forms such a leitmotiv in the Sunnyside sketchbooks, Sir Arthur began to view the imaginative powers of his father in a new light. This also applied to Charles's fairies — artistic creations which 'exist' in real terms, in quite a different way from Richard's light hearted fantasies, and which in the Sunnyside volumes are often labelled with captions stating that they are based on actual observation.

These two predominant concerns in Sir Arthur's mind do much to explain his deep interest in the Cottingley 'fairy' photographs, which was to bring such obloquy from a public distressed to see the creator of Sherlock Holmes, the great empirical investigator, committed to such a curious cause. Familiar though the story has become, via the medium of countless articles and television programmes, it is necessary to briefly recount some of the salient features of the case, although it is an extremely complex story and those interested are referred to the definitive series of articles by Geoffrey Crawley in the *British Journal of Photography*, December 1982 to April 1983.

In July 1917 Frances Griffiths, a nine year old girl, fell in the brook, or beck as the Yorkshire term has it, at Cottingley, then a village but now on the outskirts of Bradford. She got her clothes wet and when chided by her Mother and her Uncle and Aunt, Mr and Mrs Wright, with whom she and her mother was staying, she said she had been playing with the fairies which increased their anger. (She has always maintained, and continues to do so until the present day, that she did see real fairies, and that the fifth photograph in the series, taken 28 August 1920, is genuine although she was not there when it was taken).

Her cousin, Elsie Wright, then aged fifteen (now Mrs Hill) suggested that they should take Mr Wright's camera and take a photograph to confound the adult's scepticism. It was Elsie, the older partner in the enterprise, with considerable artistic gifts, who undertook most of the artwork, based on drawings of fairies in *Princess Mary's Gift Book* published in 1915. Her part in the affair was initially of a more light-hearted nature, her wish being to play a practical joke on the adult world. Through an extremely complex set of circumstances (fully discussed in *Crawley*, op. cit.) the joke misfired and the initial two photographs of July and September, 1917, and subsequent ones taken under 'controlled' conditions in August, 1920, became famous, and the deception had to be maintained, not just for a few days, but for sixty-five years.

In May, 1920 the first two photographs were sent to Edward Gardner, a keen Theosophist and believer in the paranormal, who lived at Harlesden in London. He took them to H. Snelling, a leading photographic technician of the time, who was impressed by them technically but 'improved' them considerably in copy prints. It was these copy prints which were shown to Sir Arthur Conan Doyle in June 1920, who was already working on an article on the subject of sightings of real fairies. He asked for tests to be carried out by Kodak and another photographic firm, Ilford Ltd but the results were contradictory, and he was personally most influenced by H. Snelling's "wholehearted endorsement" of the prints. From this followed two articles in *The Strand Magazine* the first in December 1920, reproducing the first two photographs, and the second in March 1921, reproducing the third and fourth photographs, taken under 'controlled' conditions in August 1920, set up while Sir Arthur was in Australia by Gardiner.

In his conclusion to the first *Strand* article can be found the most explicit statement by Sir Arthur of his motivations for accepting the photographs as genuine: "The recognition of their existence (fairies) will jolt the material 20th century out of its heavy ruts in the mud, and will make it admit that there is a glamour and a mystery to life. Having discovered this the world will not find it so difficult to accept that spiritual message supported by physical facts which has already been so convincingly put before it". The subsequent publication in 1922 of his book *The Coming of the Fairies* emphasising his commitment to the genuiness of the photographs, deepened the public bewilderment at his belief in the affair.

At this distance in time it is impossible not to sympathise with all concerned in the incident; the perpetrators, Frances and Elsie, caught up in a situation which had burgeoned out of their hands into a cause célèbre, the public, and most of all with Sir Arthur himself, caught between his family concerns with fairy lore and his own beliefs and character, such an unusual blend of the utmost integrity and deeply committed idealism. But there is, one fears, no hope at all of the story ever dying, for it has become, despite the recent confessions of the two ladies involved, one of the most potent of modern myths, on a par with the soldiers on Christmas Day in the First World War refusing to fire at each other, the cruise of the Marie Celeste and Jack the Ripper. Its file will always be taken down and dusted by editors short of sensational copy in the 'silly season' of the summer holidays — the months of July, August and September when it began sixty-five years ago.

The most famous member of the Doyle family has, after all, left us with the best fairy story . . .

LL

SIR ARTHUR CONAN DOYLE

192. A 'carte de visite' photograph of the six-year-old Arthur Conan Doyle, and his father Charles. Taken in Edinburgh, 1865.
Lent by Brigadier J.R.I.Doyle, O.B.E.

193. Mary Doyle (1838-1921) née Foley, by Richard Doyle. Pencil.
Lent by Lady Bromet, D.B.E.
A sensitive sketch by Richard of Arthur's mother, at about the time of her marriage to Charles in 1855. The drawing, which captures the determination which was such a marked feature of her character, forms an interesting comparision with the photograph of her in old age as 'The Ma'am'.

194. A family group photograph, 1904.
Lent by Brigadier J.R.I.Doyle, O.B.E.
'The Ma'am' — Mary Doyle, the centre of the seated ladies, surrounded by her family. To the left sits Louise, Lady Conan Doyle, Sir Arthur's first wife, with their son Kingsley standing

194

next to her. Behind them stands Sir Arthur, and next to him, wearing pince-nez, is his brother-in-law, the author E.W.Hornung, creator of **Raffles,** the famous story of a gentleman burglar. On the extreme left is Arthur's brother Innes (Brigadier General Doyle 1873-1919). Four male members of the group were to lose their lives as a direct result of the First World War.

195. Programme of the play '**Sherlock Holmes**' by Arthur Conan Doyle and William Gillette. Lyceum Theatre 1901.

196. Christmas card with portrait of William Gillette as Sherlock Holmes. Gillette, an American actor, so resembled the drawings of Holmes by the artist Sidney Paget that the first sight of him took Conan Doyle's breath away. They collaborated on the first of countless versions of the stories on stage and screen.
The above two items lent by the Theatre Museum.

197. Sir Arthur Conan Doyle Centenary volume, open at a page showing a photograph of Major Wood, Conan Doyle's associate and secretary, the original of Dr. Watson.

198. Photograph of Sir Arthur Conan Doyle in 1902, the year of his Knighthood.
The above two items lent by Brigadier J.R.I.Doyle, O.B.E.

199. Sir Bernard Partridge (1861-1945).
Caricature of Sir Arthur Conan Doyle chained to Sherlock Holmes.
Pen and ink.
Lent by the National Portrait Gallery.
Sir Bernard Partridge knew Conan Doyle well, for they were contemporaries at Stonyhurst. This caricature, which first appeared in Punch in May, 1926, was to influence Elsie Wright in her decision not to divulge the truth about the Cottingley fairy photographs until after Sir Arthur's death, see her letter to the **British Journal of Photography,** 1 April, 1983.

200. Photographs of the Midg Camera used by Elsie and Frances to take the 1917 photographs (a) Hand held for upright Format use and set as claimed to 1/50 sec at F/11
(b) Front door open showing shutter mechanism and prime, doublet lens.
Private Collection.

199

198

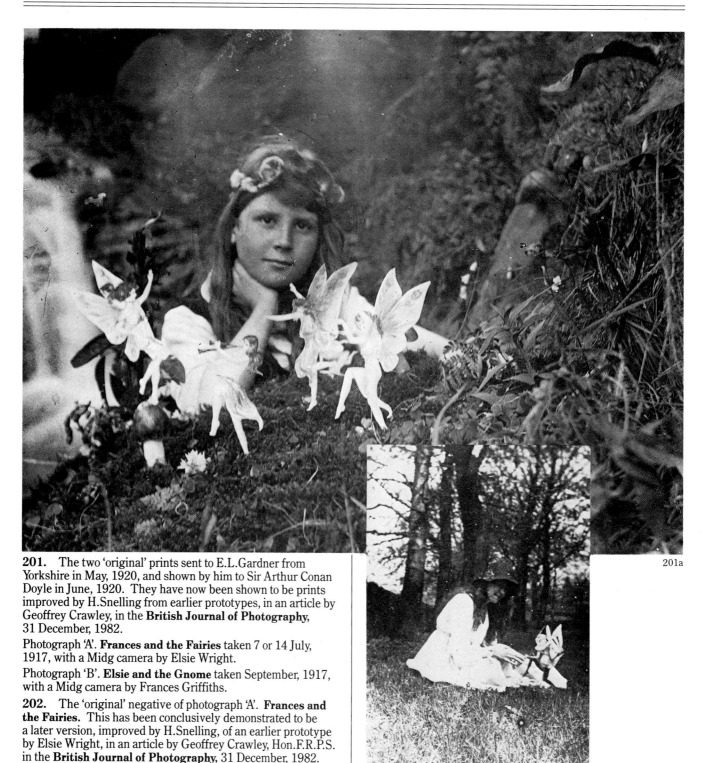

201a

201b

201. The two 'original' prints sent to E.L.Gardner from Yorkshire in May, 1920, and shown by him to Sir Arthur Conan Doyle in June, 1920. They have now been shown to be prints improved by H.Snelling from earlier prototypes, in an article by Geoffrey Crawley, in the **British Journal of Photography**, 31 December, 1982.

Photograph 'A'. **Frances and the Fairies** taken 7 or 14 July, 1917, with a Midg camera by Elsie Wright.

Photograph 'B'. **Elsie and the Gnome** taken September, 1917, with a Midg camera by Frances Griffiths.

202. The 'original' negative of photograph 'A'. **Frances and the Fairies.** This has been conclusively demonstrated to be a later version, improved by H.Snelling, of an earlier prototype by Elsie Wright, in an article by Geoffrey Crawley, Hon.F.R.P.S. in the **British Journal of Photography**, 31 December, 1982.

203. Watercolour **Fairies by a Stream** painted by Elsie Wright (aged 19) for E.L.Gardner to show her artistic ability and derided by him.

204. Later prints of the Five Cottingley Fairy photographs. All the Cottingley Fairy material 201-204. Lent by the Brotherton Collection, University of Leeds.

205. The Coming of the Fairies 1922, by Sir Arthur Conan Doyle. Lent by Jeremy Maas.

206. The Old Horse. Facsimile of drawing by Sir Arthur Conan Doyle done shortly before his death in 1930. This moving pictorial summary of his major achievements in life is notable for the very large stone representing 500 lectures, and the rather small stone representing Sherlock Holmes!

207. The Condottiere. Drawing by Adrian Conan Doyle (1910-1970). Pencil, 28.5 x 36.5 cms. Adrian Conan Doyle, the second son of Sir Arthur's second marriage, was a man of very varied interests. A sportsman and explorer, he held the British dirt track record for cars in 1936, and led zoological expeditions to the Cameroons in 1938, and on an Arab dhow to French Somaliland in the 1950's, bringing back a 1,500 lb. Tiger shark. He collected ancient arms and armour, an interest reflected in the drawing shown here, and organised a mediaeval tournament in the 1950's at his home, the Chateau de Lucens in Switzerland. Although untrained, his paintings have a disturbing, macabre power, and he also wrote several books on his travels, of short stories, and on his father's work.

208. Race Through Time. Drawing by Catherine Ruml Doyle (born 1955). Pencil 17.7 x 25.2 cms. The above three items lent by Brigadier J.R.I.Doyle, O.B.E.

206

BOOKS AND OTHER PRINTED WORKS ILLUSTRATED BY RICHARD DOYLE

The following list describes the books in chronological order according to the date of publication. Only first editions are included except in cases where significant changes or additions were made in subsequent printings.

MH

[Doyle (Richard)] The Tournament, or The Days of Chivalry Revived, oblong folio, J.Dickinson, 1840
7 lithographed plates including pictorial title on upper cover, paper wrappers
 Each plate has one or more humorous illustrations within a pictorial border recording incidents in the Eglinton reenactment of an early tournament.

[Doyle (Richard and James)] National Envelopes, Fores, 1840
10 lithographed designs, 5 by Richard, 1 by Richard and James and 4 by James, issued plain or coloured by hand
 The humorous designs parody the pictorial envelope designed by William Mulready earlier the same year. These are Richard's first published drawings.

[Doyle (Richard)] A Grand Historical Allegorical Classical and Comical Procession of Remarkable Personages Ancient Modern and Unknown. Dick Kitcat Pinxt., oblong 8vo, T.McLean, 1842
60 lithographed illustrations coloured by hand, and pictorial title on upper cover, card wrappers
 The illustrations form a panoramic christening procession for the Prince of Wales, and are virtually all reproduced from the drawings of the procession for the christening of the Princess Royal made by Richard for his father in 1840. The final figure in the procession is a self-caricature of the youthful artist.

Maxwell (W.H.) The Fortunes of Hector O'Halloran and his man Mark Antony O'Toole, one vol. in 12 parts, 8vo, Richard Bentley, [1842-43]
32 etched plates, 5 by Richard Doyle, the remainder by John Leech, printed wrappers or cloth
 These are the first etchings made by Doyle, following lessons in the technique from John Leech.

Dickens (Charles) The Chimes, sm. 8vo, Chapman and Hall, 1845 [1844]
engraved frontispiece and title by Maclise, 11 wood-engraved illustrations, 4 by Richard Doyle, the remainder by Leech, Maclise, and Stanfield, red pictorial cloth gilt

Dickens (Charles) The Cricket on the Hearth, sm. 8vo, Bradbury and Evans, 1846 [1845]
wood-engraved frontispiece and title by Maclise, 12 wood-engraved illustrations, 3 by Richard Doyle, the remainder by Landseer, Leech, and Stanfield, red pictorial cloth gilt

à Beckett (Gilbert) Almanack of the Month, 12 parts, sm. 8vo, Punch Office, 1846
180 wood-engraved illustrations and repeated cover design, paper wrappers
 The almanack appeared monthly and includes preliminary pages to form two volumes. The series was discontinued after the one year of publication.

Grimm (J.C. and W.C.) The Fairy Ring, a New Collection of Popular Tales, translated by John Edward Taylor, 8vo, John Murray, 1846
wood-engraved frontispiece, title vignette, 10 plates and cover design, blue printed boards
 This was the third collection of the Grimm's tales to be published in England, considered by W.M.Thackeray to rival that illustrated by Cruikshank.

Dickens (Charles) The Battle of Life, sm. 8vo, Bradbury and Evans, 1846
wood-engraved frontispiece and title by Maclise, 11 wood-engraved illustrations, 3 by Doyle, the remainder by Leech, Maclise, and Stanfield, red pictorial cloth gilt.

Punch's Almanack 1848, large 4to, Punch Office, [1847]
6 wood-engraved pictorial borders, one repeated border and 25 illustrations by Doyle, and other illustrations by Leech, all coloured by hand, stiff paper wrappers
 A special issue of the Almanack on better paper than the newsprint of the ordinary issue. Similar special issues for other years have not been traced.

The London Illustrated Almanack, 1848, Illustrated London News Office, [1847]
12 wood-engraved pictorial calendar headings, printed wrappers.

The London Illustrated Almanack, 1848, folio, Illustrated London News Office, [1847]
12 wood-engraved pictorial calendar headings, printed wrappers.

Hunt (Leigh) A Jar of Honey from Mount Hybla, 8vo, Smith Elder & Co., 1848
wood-engraved frontispiece and 26 pictorial initials and vignettes, decorated boards designed by Owen Jones.

[Doyle (Richard)] Selections from the Rejected Cartoons, with descriptive letterpress and critical remarks, folio, T.McLean and F.Syrett, 1848
lithographed pictorial title and 15 plates, red cloth gilt
 The plates parody the work of Maclise, Pugin, and others submitted for the Westminster Hall cartoon competition. Five are based on early "Comic Histories" drawings and another is Doyle's first major fairy picture to be published.

The Gallantee Show, 8vo, Bradbury and Evans, 1848
a two-page advertisement for publications illustrated by Doyle and Leech

Forster (John) The Life and Times of Oliver Goldsmith, Bradbury and Evans, 1848
41 wood-engraved illustrations, one by Doyle, the remainder by Hamerton, Leech, Maclise and Stanfield, cloth

Milton (John) L'Allegro and Il Penseroso, 4to, Art Union of London, 1848
30 wood-engraved plates, one by Doyle, the remainder by H.K.Browne, Corbould, Gilbert, Tenniel and others, cloth-backed printed boards

[Whitehill (Anthony)] "Anthony R.Montalba". Fairy Tales from All Nations, 8vo, Chapman and Hall, 1849
12 wood-engraved plates and 12 wood-engraved illustrations, cloth

The second edition was issued as one volume or in four separate parts titled **Snow-White and Rosy-Red; The Enchanted Crow; Fortune's Favourite;** and **The Feast of the Dwarfs.** Each part had one of the plates with additional colour as a frontispiece, published by Dean in 1871.

The third and fourth editions also published by Dean in 1890 and 1893 contain all the original plates and illustrations together with 12 plates adapted from the *Juvenile Calendar* and a vignette by Alfred Crowquill.

Zschokke (Heinrich) The Lover's Stratagem, and other Tales, 8vo, John and Daniel Darling, 1849
numerous illustrations wood-engraved by Linton, 30 for *The Lover's Stratagem* after James, Richard, and Henry Doyle, decorated boards

Most of the Doyle illustrations are signed with monograms of initials, and from these and the style of the unsigned designs it would appear that Richard contributed seven illustrations, James five, and Henry eighteen.

Doyle (Richard) Manners and Customs of ye Englishe, to which be added some extracts from Mr Pips hys Diary contributed by Percival Leigh, 2 vol. in one, oblong 4to, Bradbury and Evans, 1849
40 wood-engraved plates and decorated title, half roan with title repeated on upper cover

The work first appeared in serial form in *Punch.* Later editions include one in French, 1851; and one edited by Michael Sadleir retitled **God's Englishmen,** 1948.

Hervey (Mrs T.K.) Juvenile Calendar and Zodiac of Flowers, 8vo, Sampson Low & Son, 1849
wood-engraved pictorial title and 12 plates, red pictorial cloth gilt

The woodblocks were acquired by Dean and adapted to illustrate several later publications.

The Book of Ballads, edited by Bon Gaultier [Sir T.Martin], 8vo, W.S.Orr & Co., 1849
61 wood-engraved illustrations, 16 by Doyle, the remainder by Crowquill, Leech and Meadows, cloth gilt

This is an enlarged edition of the work first published in 1845 with the illustrations entirely by Crowquill. Variations occur in the many later editions. The thirteenth edition and possibly others omit one of Doyle's illustrations but include a further seven not in the 1849 printing.

Lemon (Mark) The Enchanted Doll, 8vo, Bradbury and Evans, 1850 [1849]
wood-engraved frontispiece and pictorial title, 21 illustrations, initials and decorations, printed boards

The story was reissued in **Fairy Tales** by Mark Lemon in which 1 decoration and 1 initial were omitted. Two new initials by Richard Doyle and two others by Charles Bennett were added, as well as the latter's illustrations to the other tale in the book "Chronicles of the Three Sisters". **The Enchanted Doll** was later published separately in miniature format by Wells Gardner, Darton & Co. in 1899.

[Thackeray (W.M.)] "M.A.Titmarsh". Rebecca and Rowena, a Romance upon Romance, 8vo, Chapman and Hall, 1850 [1849]
wood-engraved frontispiece, pictorial title, 7 plates and 2 vignettes, pink printed boards, issued plain or coloured by hand

The Story of Jack and the Giants, 4to, Cundall & Addey, 1851 [1850]
wood-engraved frontispiece, pictorial title, 6 plates and 27 illustrations and initials, decorated red cloth gilt, issued plain or coloured by hand

[Ruskin (John)] The King of the Golden River, a Legend of Stiria, 8vo, Smith Elder & Co., 1851 [1850]
wood-engraved frontispiece, pictorial title, 22 illustrations and initials, and 2 designs on upper cover, yellow printed boards

The frontispiece of the first and second editions was changed in later printings to substitute a conventional nose for the hooter-like one in the original design.

Doyle (Richard) An Overland Journey to the Great Exhibition, showing a few extra articles and visitors, oblong 8vo, Chapman and Hall, 1851
wood-engraved panorama in 16 sections, printed boards with title on upper cover, issued plain or coloured by hand

This humorous comment on the nations and their produce was reissued by the same publisher as 8 double-page plates, retitled **Richard Doyle's Pictures of Extra Articles and Visitors to the Great Exhibition,** probably in 1852.

[Thackeray (W.M.)] The Newcomes: Memoirs of a Most Respectable Family, edited by Arthur Pendennis Esq., 2 vol. in 24 parts, 8vo, Bradbury and Evans, [1853]-1855
50 etched plates including frontispieces and pictorial titles, 118 wood-engraved initials, illustrations and vignettes, yellow printed wrappers or cloth

Doyle (Richard) The Foreign Tour of Messrs Brown, Jones, and Robinson, 4to, Bradbury and Evans, 1854
wood-engraved pictorial title and 174 captioned illustrations, blue cloth gilt reproducing title on upper cover
This was one of Doyle's most popular books, quickly pirated in New York, and imitated in *The American Tour of Messrs Brown, Jones and Robinson,* New York, 1872; and *The Foreign Tour of Misses Brown, Jones and Robinson,* [c1885?]

Landon (Letitia Elizabeth) Poetical works, 2 vol., 8vo, Longman, Brown, Green, and Longmans, 1855
wood-engraved illustration on each title-page, cloth

Merry Pictures by the Comic Hands of H.K.Browne, Crowquill, Doyle, Leech, Meadows, Hine and others, oblong folio, Kent and Co., 1857
numerous wood-engraved illustrations on 42 pages by Doyle and others, pictorial boards with cover design by Alfred Crowquill

[Hughes (Thomas)] The Scouring of the White Horse, 8vo, Cambridge and London, 1859 [1858]
wood-engraved double-page pictorial title, 18 illustrations and initials, and cover design, pictorial blue cloth gilt
Some copies were issued in a special presentation binding for the author.

Cousens (Mrs Upcher) Sunday Employment, Sunday Enjoyment, 8vo, Dean & Son, [1859]
wood-engraved title printed from an adapted block originally made for the *Juvenile Calendar* with added colour, red cloth gilt

Grove (Eliza) The Adventures of a Sunbeam & other Tales in Verse, sm. 4to, Dean & Son, [1859]
wood-engraved pictorial title printed from an adapted block originally made for the *Juvenile Calendar,* numerous other illustrations by different artists, decorated cloth gilt

Procter (Adelaide) A Chaplet of Verses, 8vo, Longman, 1862
wood-engraved title vignette, pictorial cloth gilt

Doyle (Richard) Bird's Eye Views of Society, oblong folio, Smith Elder & Co., 1864
wood-engraved pictorial title, 6 plates, and 16 pictorial initials, half roan, title reprinted on upper cover
The plates first appeared in serial form as folding illustrations in *The Cornhill Magazine,* 1861 and 1862.

Gouraud (Julie) The Adventures of a Watch, 8vo, Dublin, James Duffy, [1864]
wood-engraved frontispiece and pictorial title, decorated cloth gilt

Locker (Frederick) A Selection from the Works, 8vo, Edward Moxon & Co., 1865
wood-engraved title vignette and 18 illustrations, some incorporating titles of the poems, decorated cloth gilt

Planché (J.R.) An Old Fairy Tale Told Anew, 4to, George Routledge & Sons, [1865]
wood-engraved frontispiece and 18 illustrations, 5 full-page, one illustration repeated in reduced form as title vignette, brown pictorial cloth gilt
Both the illustrations and text were commissioned by the Dalziel Brothers. Doyle was invited to supply the drawings to illustrate *The Sleeping Beauty* in 1850, to which Planché wrote the accompanying text in verse.

The Visiting Justices and The Troublesome Priest, or Irish Biddy in the English Gaol, 4to, Richard Bentley, 1868
9 illustrations, paper wrappers

Cholmondeley-Pennell (H.) Puck on Pegasus, 8vo, George Routledge, 1869
wood-engraved plates including one by Doyle, the remainder by Leech, Millais, Paton, Tenniel and others, green cloth
This is a "new edition", possibly based on an earlier printing of 1862.

Burlesques, Novels by Eminent Hands, 8vo, New York, Caxton Publishing Co., [?1869]
illustrations by Doyle and W.M. Thackeray

Doyle (Richard) In Fairyland, a Series of Pictures from the Elf World with a Poem by William Allingham, folio, Longmans, Green, Reader & Dyer, 1870 [1869]
wood-engraved pictorial title, 16 coloured plates with 36 illustrations and 3 initials, and cover design, green decorated cloth gilt
The text was specially written to accompany the drawings contained in what is without any doubt the best of Doyle's illustrated books. It is a masterpiece of Victorian colour printing by Edmund Evans.

Oliphant (Laurence) Piccadilly, a Fragment of Contemporary Biography, 8vo, Edinburgh and London, William Blackwood & Sons, 1870
8 wood-engraved illustrations and cover design, green pictorial cloth gilt

The Attractive Picture Book, oblong folio, Griffith & Farran, [c. 1875]
numerous wood-engraved illustrations from previously published books, including 19 by Doyle from *Jack and the Giants,* cloth-backed printed boards

Knatchbull-Hugessen (E.H.) Higgledy-Piggledy, 8vo, Longmans, Green, 1876
wood-engraved title vignette and 8 plates, green pictorial cloth gilt

Benjamin Disraeli, Earl of Beaconsfield, KG, in upwards of 100 Cartoons from the collection of Mr. Punch, 4to, Punch Office, 1878
numerous cartoons including "Gulliver and Brobdingnag Farmers" by Doyle

Lang (Andrew) The Princess Nobody, a Tale of Fairy Land, 4to, Longmans, Green & Co., 1884
55 wood-engraved illustrations, 25 in colour, the remainder in sepia or brown, one repeated as pictorial endpapers, one in two sections on covers, cloth-backed pictorial boards
 The illustrations are those for *In Fairyland,* adapted to combine with the specially written story by Lang to form a new book.

Doyle (Richard) Dick Doyle's Journal, introduction by J. Hungerford Pollen, 4to, Smith Elder & Co., 1885
facsimile reproduction of the manuscript journal illustrated with numerous pen and ink drawings, pictorial cloth gilt
 The 152 page journal is the most important source for Doyle's early interests and work, including his comic histories, his recording of social events and everyday life, the christening procession, and the influence of his father on his own and family activities.

Doyle (Richard) Comic Histories, with the Startling Story of Tommy and the Lion, oblong 4to, Pall Mall Gazette Office 1885
12 illustrations reproducing drawings in the "Comic Histories" series, and 12 illustrations reproducing drawings and manuscript text for a cautionary tale, apparently issued unbound
 The comic histories drawings were made in 1840 for an illustrated manuscript with text by James Doyle, and water-colour illustrations and ink initials and vignettes by Richard. *Tommy and the Lion* was one of his last sets of drawings for a story in pictures.

Doyle(Richard) Scenes from English History, oblong 4to, Pall Mall Gazette Office, 1886
12 coloured plates and tailpiece, portrait frontispiece, and pictorial border to title adapted from one originally made for *The Tournament,* pictorial cloth
 The plates are those of the preceding item printed in colour, with James Doyle's text.

[Doyle (Richard)] Homer for the Holidays, by a Boy of Twelve, oblong 4to, Pall Mall Gazette Extra, 1887
15 plates captioned with extracts from Pope's translation, apparently issued unbound
 The drawings were made in 1836 and form the earliest series of drawings by Doyle to be published. Although printed in outline like the first publication of the *Comic Histories* both sets of illustrations were done in ink and watercolour.

Jack the Giant Killer, 4to, Eyre and Spottiswoode, [1888]
facsimile reproduction of the manuscript illustrated with 55 watercolour drawings, each of the 48 pp. within a different pictorial border, pictorial cloth
 This is one of two illustrated manuscripts known to have been completed, produced in 1842. Various others are known from drawings cut from unfinished works of a similar nature.

Johnson (Charles Plumptre) The Early Writings of Thackeray, 8vo, Elliot Stock, 1888
numerous illustrations including some by Doyle reprinted from earlier works

Sinclair (Dorothea) The Enchanted Princess, 8vo, Dean & Son, [c. 1890]
9 illustrations by Doyle, one from *Juvenile Calendar,* 8 from Montalba's *Fairy Tales of All Nations;* and others by Arthur Hitchcock

The Queen and Mr. Punch, the Story of a Reign told by Toby MP, 4to, Bradbury, Agnew and Co., [1897]
numerous illustrations, a preliminary vignette and the final tailpiece by Doyle, pictorial wrappers

Wyndham (Madeline) The Sad Story of a Pig and a Little Girl, 8vo, [Privately Printed], 1901
9 illustrations, paper wrappers
 The illustrations were made in 1876 to accompany this youthful story, written when the author was 6 years old.

The Brothers Dalziel, a Record of Fifty Years, 4to, Methuen, 1901
numerous illustrations, including 4 by Doyle

[de la Mare (Walter)] "Walter Ramal". Songs of Childhood, 8vo, Longmans & Co., 1902
frontispiece reproducing the painting "Fairies under a Tree", boards

Jerrold (Douglas W.) Mrs. Caudle's Curtain Lectures, 8vo, R. Brimley Johnson, [1902]
numerous illustrations and initials previously published in *Punch,* including 25 by Doyle

John Bull's Year Book, edited by Arthur à Beckett, 8vo, John Bull Press, 1903
various illustrations, including 16 by Doyle previously published in Gilbert à Beckett's *Almanack of the Month,* 1846

Doyle (Richard) Pictures, 4to, London and Glasgow, Gowans & Gray, 1907
various illustrations reprinted from *Bird's Eye Views of Society; Manners and Customs of ye Englishe;* and *The Foreign Tour of Brown, Jones and Robinson*

Mr. Punch's Pageant, sm. 4to, Leicester Galleries, 1909
various illustrations including 2 by Doyle

Beauty and the Beast, translated by Adelaide [Doyle], introduction by Charles Ryskamp, 4to, New York, Pierpont Morgan Library, 1973
facsimile reproduction of the illustrated manuscript produced c. 1842, with pictorial title and dedication, 35 illustrations, and pictorial borders on first and last pages

Periodicals

Richard Doyle's early reputation was made through his work for Punch. He contributed to the magazine from 1843 until his resignation in 1850, and during this period produced the cover design first used in 1844, several series of illustrations, various full-page cartoons, and numerous small designs and pictorial initials totalling over 1000 drawings in all.

Other work for periodicals can be found in Fraser's Magazine, 1842-1844; Illustrated London News, 1848-1851; The Ladies' Companion at Home and Abroad, 1849-1850; and The Cornhill Magazine, 1861-1862.

Reference Works

A number of the later nineteenth-century books listed above have short biographical introductions written in memory of Richard Doyle. The first book devoted to his life and work was Daria Hambourg's Richard Doyle, published by Art and Technics in 1948. In the last 10 years a number of catalogues for exhibitions in England and America have included reproductions of his paintings and drawings, and further information. The first full-length biography has been written by Rodney Engen and published by the Catalpa Press to coincide with the present exhibiton.

MH

164

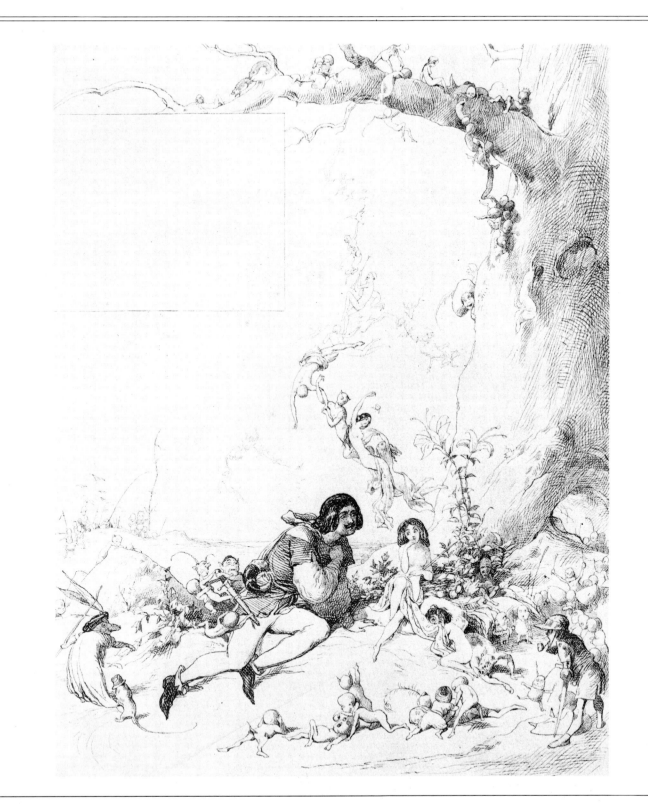

129